CONTENTS

Introduction	5
The Support	23
The Design	47
The Painting	63
The Finishing Touches	91
Further Reading	94

4

Jo Kirby was formerly a staff member of the Scientific Department at the National Gallery, London, and is a world-renowned expert in the history of painting materials. She has contributed to the National Gallery's *Art in the Making* series in titles on Rembrandt, Impressionism, and Degas, and also to the *National Gallery Technical Bulletin*.

First published in Great Britain in 2011 by
National Gallery Company Limited
St Vincent House, 30 Orange Street, London WC2H 7HH
www.nationalgallery.co.uk
ISBN: 978 1 85709 534 0
1032230

British Library Cataloguing-in-Publication Data
A catalogue record is available from the British Library
Library of Congress Catalog Card Number: 2011920740

FRONT COVER Vincent van Gogh, *A Wheatfield, with Cypresses*, 1889, detail.
TITLE Claude-Oscar Monet, *Irises*, about 1914–17, detail.
CONTENTS PAGE Attributed to Jacopi di Cione and workshop, *Adoring Saints: Left Main Tier Panel, San Pier Maggiore Altarpiece*, 1370–1, detail.

All National Gallery images in this book can be viewed online at www.nationalgallery.org.uk. The Gallery's website has a helpful zoom facility, where you can view images in more detail.

MANAGING EDITOR Jan Green
PROJECT EDITORS Rachel Giles and Claire Young
EDITOR Emily Winter
PICTURE RESEARCHER Suzanne Bosman
PRODUCTION Jane Hyne and Penny Le Tissier
DESIGNER Stuart Bicknell
COVER ARTWORK Smith & Gilmour
Printed in Hong Kong by Printing Express Ltd.

INTRODUCTION

I f we look around at the walls of an art gallery, we are
faced by a sea of coloured surfaces. When we look
more closely, we can see that each surface is an image,
created using coloured paint, but in such varied ways that
each painting looks different from its neighbours. How have
the artists achieved this? Why does a painting produced in
fourteenth-century Siena look so different to one painted
in France in the late nineteenth century [1, 2]? It is true
that they were made for different purposes – one is a small
religious painting, the other an informal landscape – but are
there other reasons? Did the artists have different materials to
choose from, or did they simply use them differently? How
were they able to achieve such a range of effects and styles,
often so distinctive that we can place a work within a certain
period, or even attribute it to a particular painter?

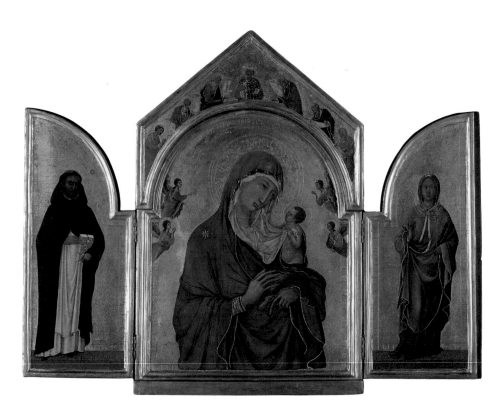

This book sets out to explain how painters used the materials at their disposal, drawing on the National Gallery's collection of paintings from western Europe, ranging in date from the thirteenth to the early twentieth century. If we have some understanding of how a painting is made, we have an insight into the artist's time and place. We can begin to see why the artist made particular decisions about the design of the painting. We can appreciate how, and perhaps why, the painting has changed in the hundreds of years that have elapsed since the day it left the artist's easel. We can also use what we have learnt to give the painting all the care it needs today to ensure its survival for the future.

We should remember that none of the paintings are displayed in the context for which they were created. A high proportion have a religious, and specifically Christian, subject matter and were made for churches or other religious foundations, or for private devotion. The early Italian panel paintings, now hanging on light-coloured gallery walls, stood on or behind altars in the low half-light of churches, where the light of candles would have flickered on their gleaming, golden surfaces. The large religious or mythological scenes painted on canvas may formerly have

Previous pages: Claude-Oscar Monet, *Bathers at La Grenouillère*, 1869, detail.

1. Duccio di Buoninsegna, *The Virgin and Child with Saints Dominic and Aurea*, about 1312–15(?).

been mounted at a great distance from the viewer, perhaps on the ceiling of a huge room. We are seeing them closer than the artist intended and adjustments the artist made to the proportions to take account of the original position may now look very odd. Details that look sketchy from a distance of a metre would look perfectly satisfactory from five metres away. Even the most modern paintings in the collection, those by French Impressionist painters like Claude Monet, would have been displayed rather differently, on dark red-brown gallery walls, when they were first painted.

Studying Paint Structure

Paint is made up essentially of two ingredients: the pigment, which gives the colour, and the binding medium, which serves to bind the pigment grains together into a paste and gives the paint its consistency and working properties. The binding medium is primarily responsible for the way in which the paint flows off the brush and can be manipulated, and each medium – oil, egg tempera, gum or glue – has its own characteristic properties. Paint containing a gum that can be mixed with water, such as the cakes of colour found in a watercolour paint box, can be used to give areas of transparent wash, but cannot easily be built up into

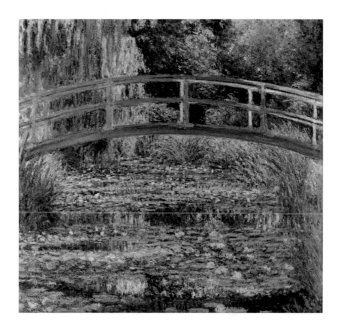

2. Claude-Oscar Monet,
The Water-Lily Pond, 1899.

areas of thick, dense colour: the paint is too brittle and cracks. On the other hand, slow-drying oil paint can be blended, built up into solid, heavily applied colour, or brushed out in thin, dry, sketchy strokes in a way that is quite impossible with a rapidly drying water-based binder like watercolour, glue distemper or egg tempera. Pigment and medium together give the paint its properties of opacity or translucency; the light, bright appearance of egg tempera paint or the saturated colour of oil paint [3, 4].

Most of the paintings in the National Gallery's collection are in oil or in egg tempera; the acrylic paints invented in the 1950s are too recent to be present on National Gallery paintings. Egg tempera was used by Italian painters until about 1470/80; across northern Europe, on the other hand, the preferred medium was oil. Thus all the egg tempera paintings in the collection are Italian, dating from before 1500. Later, persuaded by the extraordinarily convincing effects northern artists were able to obtain, Italian painters began to use oil as well.

The paint we see is only the final stage in the process: the artist carried out a great deal of work beforehand, and beneath the painted surface there is quite a complex structure. We can learn something of this from unfinished paintings and we can consult written evidence, but at a deeper level, the National Gallery is

3. Andrea del Verrocchio and assistant (Lorenzo di Credi), *The Virgin and Child with Two Angels*, about 1476–8. Detail of the landscape behind the Virgin's right shoulder. The application of paint in fine parallel strokes seen in the blue robe is typical of egg tempera. The artist has added more water to his medium to paint the distant hills with washes of pale colour. See also [91].

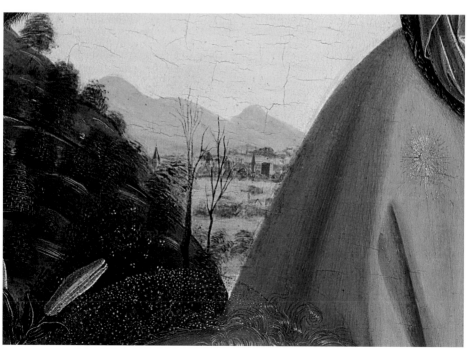

able to amplify this information through its scientific research and conservation work, looking at the paint under higher magnification, analysing the materials present and investigating the deeper structure. X-radiography of the painting, for example, can reveal changes to the composition made by the artist at an early stage; infrared reflectography, a technique using infrared radiation, can make visible the artist's drawing beneath the paint. Examples of the use of these techniques are given later in the book, but the reader can also learn more from another book in this series: *A Closer Look: Deceptions and Discoveries*, by Marjorie E. Wieseman (2010).

A great deal can be learned by studying the paint surface under higher magnification, as is often done during conservation treatment. The paint layer structure can be studied in great detail under the microscope, using a cross-section prepared from a tiny sample of the paint obtained from a damaged area. In *The Virgin and Child Enthroned, with Four Angels* [5], the Antwerp painter Quinten Massys has painted the Virgin's drapery a subtle, cool silvery red. Looking at the paint under higher magnification we can see how this was done. The artist has applied translucent red oil paint very thinly over a darker underpaint; he must have found the paint too thick, however, as he then blotted it with

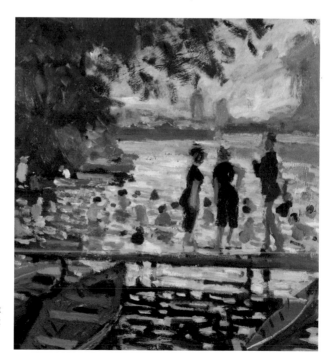

4. Claude-Oscar Monet, *Bathers at La Grenouillère*, 1869. Detail of bathers, right. The strokes of blue, cream and grey oil paint used for the water are applied freely and rapidly, one on top of the next, blending the colour on the canvas itself. The colour of the more distant water is given by light, opaque paint and the bathers in the water are mere dabs of grey paint.

9

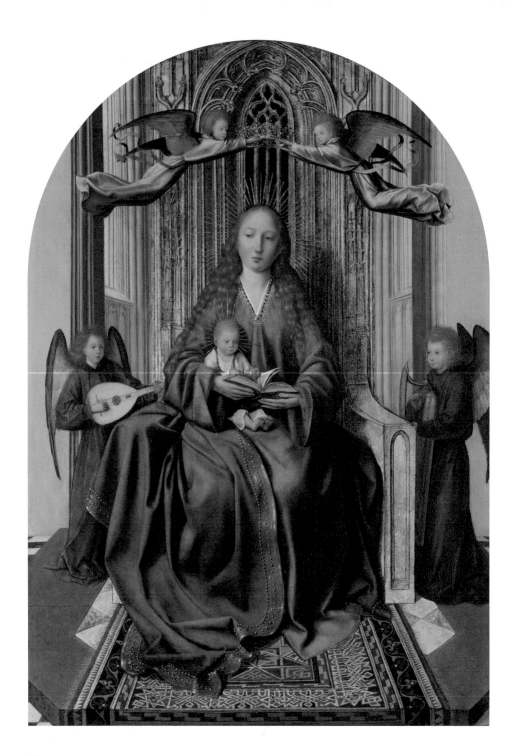

Opposite page: 5. Quinten Massys, *The Virgin and Child Enthroned, with Four Angels*, about 1495.

This page, top: 6. *The Virgin and Child Enthroned, with Four Angels*, detail of the Virgin's red cloak. At high magnification, the blotted red paint can be seen. The pearls and pale yellow decoration have been painted on top, using a dab of grey paint for each pearl with a touch of white for the highlight. The fluid red paint is used again, thinly applied, for the shadows of the pearls; it has tended to form a drop each time the artist has lifted his brush away.

This page, bottom: 7. *The Virgin and Child Enthroned, with Four Angels*. Cross-section of a sample from the red cloak, showing the thin, translucent red layer over grey paint, consisting of lead white mixed with black. Below this is a thin lead white layer and the chalk-containing preparation layer, or ground. The paint sample is no bigger than a salt grain.

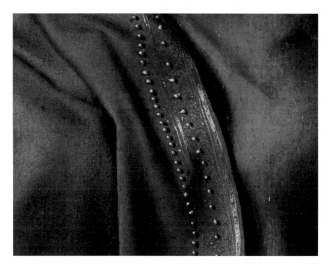

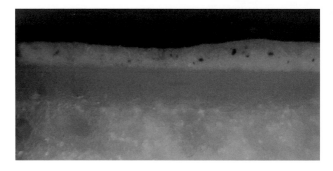

a fine linen cloth to remove the excess [6]. A cross-section [7], prepared from a sample of the paint and photographed under the microscope, shows that the red paint is indeed almost as translucent as glass and has been applied over a layer of grey paint, resulting in the subdued red colour we see.

A few of the paintings in the National Gallery's collection are unfinished. They allow us to see how artists constructed their paintings and the order in which the different parts of the picture were painted may also be revealed. Thomas Gainsborough began the painting of his two daughters [8] by sketching the composition on the beige-brown preparatory layer, or ground; he used a white chalk, traces of which can be seen in the lower right corner. He then outlined the figures with deft strokes of dark brownish paint. The placing of the cat on the older girl's lap is not entirely clear and Gainsborough did not develop this part of the picture any further. He indicated the main features of flesh and costume very sketchily – the flesh colour of the arms

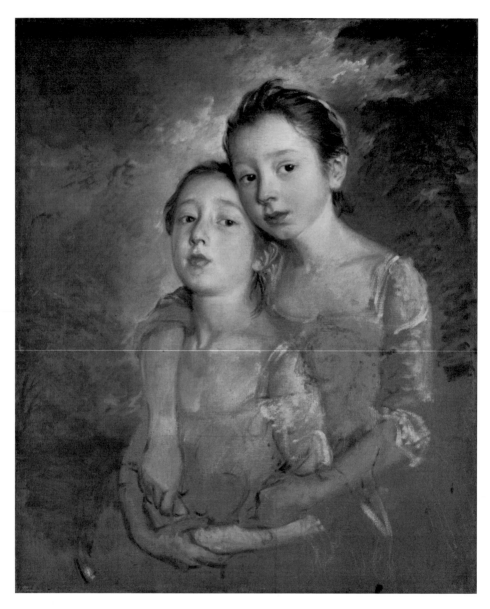

is shown, but their structure in terms of light and shade is still undefined, and the sleeves of the girls' dresses are suggested by a few quick strokes of rather dry paint – and then concentrated on the girls' heads. These are painted with a high degree of finish, even down to the tiny highlights on the tips of their noses. Gainsborough coloured the landscape behind with browns, blues, mauves and yellow, giving a generalised impression of foliage and sunlit clouds. Even in its unfinished state, however, the landscape fulfils the artist's aim of setting off the dark hair and fresh complexions of the girls very effectively.

Written evidence may take many forms: lists of materials; artists' manuals; biographies; letters, and others. Vincent van Gogh is well known for the vivid descriptions of his working methods in his letters, many of which were written to his brother Theo, but most painters did not describe their painting practice at any great length. Quite often, however, their friends or admirers give some information on how they went about their work in more or less contemporary accounts.

The handbooks, manuals and collections of workshop recipes for artists and craftsmen, sometimes written by practising painters, are among the most valuable sources of general information on studio practice. The best known is probably *Il libro dell'arte*, known in the most widely available English translation as *The Craftsman's Handbook*, written by the Florentine artist Cennino d'Andrea Cennini around 1400. Cennini claimed the source of his knowledge came from the the famous Florentine painter Giotto (who lived about a century earlier), through his pupil Taddeo Gaddi and Taddeo's son Agnolo, who was Cennini's teacher. It is not certain that any paintings that can be attributed to Cennini have survived, but comparison of the instructions he gives with paintings by late fourteenth-century Florentine artists, such as Nardo and Jacopo di Cione [9, 58], show that the procedures he describes were actually followed to a large extent. Cennini's handbook thus provides a useful illustration of the work of a Florentine artist in the years around 1350–1400, but written descriptions or recipe collections can be found for most of the periods and geographical regions represented in the National Gallery Collection.

The Artist's Studio

The fifteenth- or sixteenth-century painter's studio was very much more than a room where the artist sat alone, conveying an idea to panel or canvas. Painting was a craft that had to be learnt and the studio, or workshop, was where training took place. A student, perhaps as young as 10 years old, would be apprenticed to a painter. After learning to draw, the young apprentice would spend several years studying all aspects of painting, perhaps in more than one studio, until eventually the successful student was qualified to practise as an independent painter. The art schools of today did not then exist and early academies, founded during the sixteenth and seventeenth centuries, taught drawing, but even into the nineteenth century the mechanics of painting were taught in the studio.

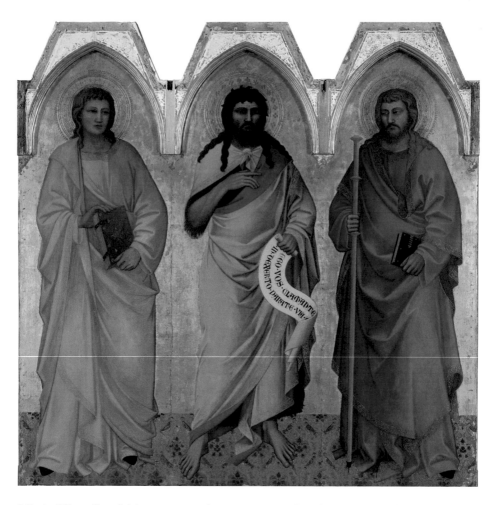

9. Nardo di Cione, *Three Saints*, about 1365.

Making pictures was also a business; successful painters often ran very large workshops and might produce a great range of painted goods, including ephemeral items like scenery for plays or festivities, as well as works of art for churches and palaces.

Easel

Much of the equipment in a fifteenth- or sixteenth-century painter's studio is easily recognisable to us today. The easel used by Saint Luke painting the Virgin Mary, as depicted by a follower of Quinten Massys [10], and those in the engraving designed by Joannes Stradanus [Jan van der Straet] [11], particularly that on the left, are not very different from some used today. Saint Luke could alter the height of the ledge upon which his painting rests by inserting the supporting pegs into different holes; the easel

10. Follower of Quinten Massys,
*Saint Luke painting the Virgin and
Child*, about 1520?

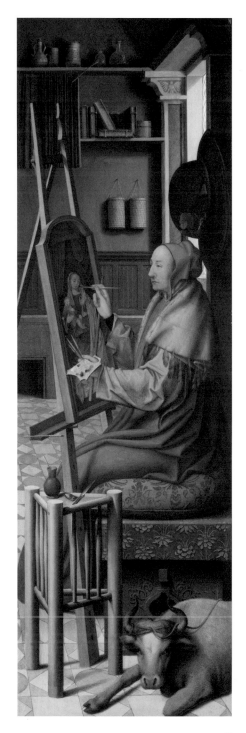

used by Eva Gonzalès, painted by Edouard Manet in 1870 [12], can be raised and lowered more conveniently by a handle at the front and these, too, are still in use.

The panel Saint Luke is working on is already in its frame. Until the sixteenth century it was not unusual to attach the frame to smaller panels before painting; indeed, occasionally the painting surface was carved out of the wood, leaving a plain moulding around the edge forming the frame; the ground, or preparatory layer, was then applied to both painting surface and frame.

Paint preparation

On the right-hand side of Stradanus's studio two well-muscled assistants are grinding pigment with oil, using grinding stones known as mullers on slabs of very hard stone, possibly porphyry. This was hard work, not a job for the small boys drawing, the youngest students in the workshop. Once ground, the paint could be placed in mussel shells or small dishes, ready for the boy in the foreground to transfer each colour to the palette using a palette knife. As we shall see, oil paint is stiff and remains in place on a flat palette; egg tempera paint is liquid and must be kept in a shell or dish.

Palette

The palette changed its shape and size over time, from the small palette held by Saint Luke [13] to the larger, rectangular palette used by the seventeenth-century Spanish painter Bartolomé Murillo [14]; some of his contemporaries used oval palettes, similar, if somewhat smaller, to that used by Eva Gonzalès two centuries later. The palettes have been arranged in an ordered way: Saint Luke keeps the reddish tones separate from the white and blue; Murillo's, with its large dab of white and then a yellow, two reds and brown, was perhaps set out especially for the painting of flesh tones.

Brushes

Early brushes were of two types. Those for coarse work were made of hogs' bristles. Fine brushes could be made of several types of hair, but the best were made from the tails of ermine (a member of the weasel family). These, like the so-called sable brushes of today, would keep a good point while being able to carry a sufficient quantity of paint. The hairs were tied in a small, round bunch and inserted into quills, which could be the feathers from a goose or a very much smaller bird. Metal ferrules

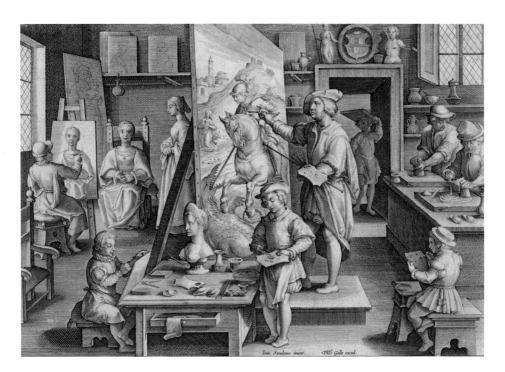

11. After Joannes Stradanus [Jan van der Straet], *Color olivi*; no. 14 in the *Nova Reperta* series. Antwerp, about 1580–1605. Rijksmuseum, Amsterdam. Note the men grinding pigments with oil on stone slabs, using heavy stone mullers. One man is adding more oil to the paint. A palette knife is used to scrape the paint back to the centre of the slab during grinding.

– the part of the brush into which the hairs are inserted – only became available late in the sixteenth century. The brush handle was inserted into the other end of the quill. Murillo's brushes are larger than Saint Luke's; the largest seems to be simply tied, without a quill, which was done for bristle brushes. Two of the brushes held by Eva Gonzalès, which have metal ferrules, appear to be the fairly broad, flat brushes known today as flats. A significant advantage of metal ferrules is that they can be shaped to give flatter brushes and a greater range of brush shapes, and these contribute to the effects painters are able to achieve as they work.

Both Saint Luke and Eva Gonzalès are using a mahlstick to support their hands while painting; this has one end padded so that it could rest safely against the painting.

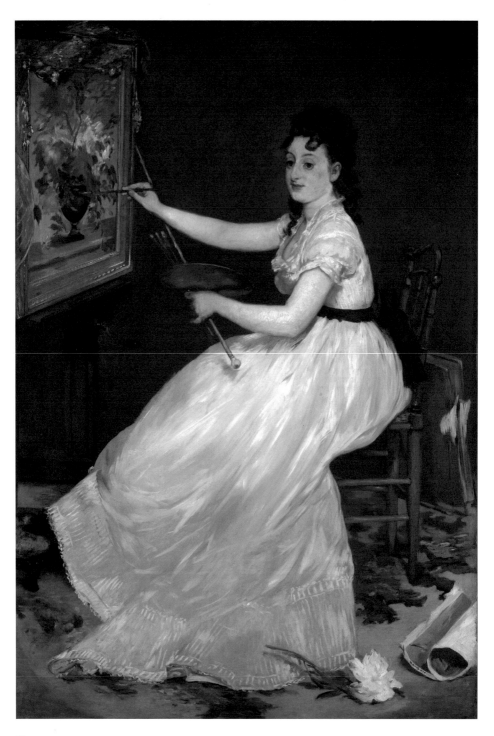

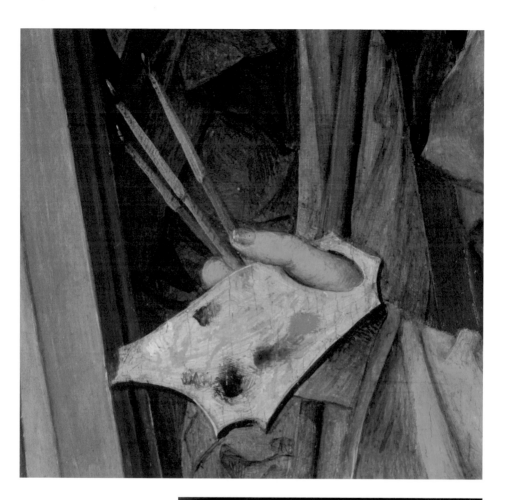

Opposite page: 12. Edouard Manet, *Eva Gonzalès*, 1870.

Above: 13. *Saint Luke painting the Virgin and Child*. Detail showing palette and brushes. The paints on the palette include bright red vermilion, a crimson lake, blue azurite and lead white. A flesh colour has been mixed in the centre of the palette. See also [10].

Right: 14. Bartolomé Esteban Murillo, *Self Portrait*, probably 1670–3. Detail showing palette and brushes. The texture of oil paint is particularly clear in the representation of the lead white.

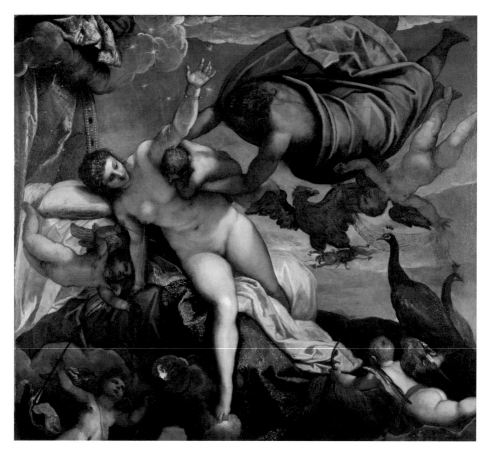

15. Jacopo Tintoretto,
The Origin of the Milky Way,
about 1575.

Other equipment

The jointed lay figure, similar to a doll with moveable limbs that can be posed, was in use in the seventeenth century; the making of a lay figure is described in a Dutch treatise of 1636 and 'a wooden manikin with its stand' is listed in the 1632 inventory of the Antwerp painter Adriaen Brouwer. Other aids could include small figures draped with cloth that could be stiffened with glue solution or something similar, ideal for studying the folds in drapery. Models might be made of difficult motifs, such as flying or falling figures. In his biography of the Venetian painter Jacopo Tintoretto, Carlo Ridolfi describes how Tintoretto, having made little houses of wood and cardboard, 'also hung some models by threads to the roof beams to study the appearance they made when seen from below, and to get the foreshortenings of figures for ceilings, creating by such methods bizarre effects'. This would certainly have helped in the composition of *The Origin of the Milky Way*, in which Jupiter hovers at the top of the scene while

16. Paul Delaroche, *The Execution of Lady Jane Grey*, 1833.

putti (winged babies, derived from Graeco-Roman mythology) swoop from every angle [15].

The construction of model buildings to study lighting effects was not unique to Tintoretto. The nineteenth-century painter Edward Armitage, who studied in Paris with Paul Delaroche in the late 1830s, describes the use of a box with a window cut in the side into which model figures could be placed and illuminated as the artist required: 'In my early days in Paris, when *pictures* were painted, and not single figures for the market, almost every young artist had his little puppet show, into which he was continually peeping during the progress of his work.' Delaroche was described by Armitage as having 'great dramatic power and exquisite taste in the arrangement of his figures' and we can imagine him using such a box and small figures while composing the highly theatrical *The Execution of Lady Jane Grey* [16].

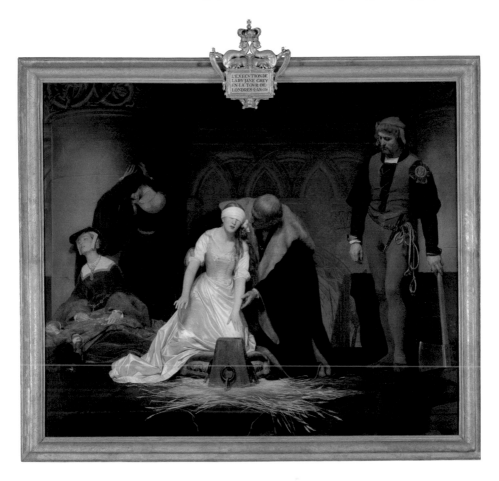

16. Paul Delaroche, *The Execution of Lady Jane Grey*, 1833.

THE SUPPORT

Before artists could begin to paint, they had to decide on the painting surface: the support. This was often dictated by the purpose of the painting, why it was being painted and for whom; thus the choice of support was not necessarily under the artist's control. Many of the paintings in the National Gallery were painted on commission, and the choice of panel, canvas or, indeed, the actual walls and ceiling of a chapel or room, was often made by the person or organisation commissioning the work.

Commissions or contracts for paintings can be very informative: sometimes the quality of the most expensive materials – the gold or silver leaf and the blue pigments – is specified; sometimes the subject matter is described. These documents may also state what was expected of the artist. According to a 1308 agreement for the *Maestà*, painted for the high altar of Siena Cathedral, the painter Duccio di Buoninsegna was to work continuously on the painting and should work 'with his own hands'. This is a fairly common stipulation in contracts: painters ran busy workshops with apprentices and assistants who did some of the painting, so the person giving the commission might wish to ensure that the master actually applied his brush to the task. In return, he was to receive a salary and the clerk of the works also promised to supply all the materials necessary for the panel to be completed. The enormous and complex altarpiece was installed in Siena Cathedral three years later in 1311 [17].

The majority of paintings in the collection are on wood or canvas supports. Put simply, the earlier paintings were painted on wooden panels; very gradually canvas, which is more easily portable, came to be preferred, at first in sixteenth-century Italy, around Venice and Verona, rather later in northern Europe, and became the most commonly used support. A substantial minority of paintings are on metal plates or paper, while wall paintings are represented by a number of frescoes, transferred from their original location.

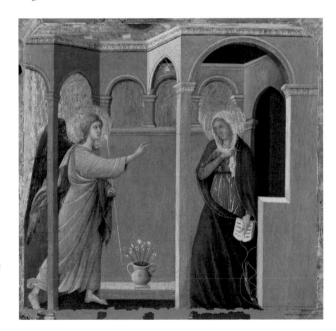

Previous pages: Michelangelo, *'The Manchester Madonna'*, about 1497, detail.

17. Duccio di Buoninsegna, *The Annunciation*, 1311. This small panel is from the predella, the horizontal structure supporting the main altarpiece panels, of the *Maestà*.

Other supports, such as parchment, ivory and stone, were important historically, but are not well represented in the National Gallery. Parchment, which is more commonly associated with illuminated manuscripts, provided a smooth and not too absorbent surface for oil painting and had the added advantage of being easily portable, while ivory was used as a support for miniature paintings. Stone, including dark grey slate, was quite widely used in Italy and Spain during the sixteenth and seventeenth centuries.

Panel

Most paintings in the National Gallery dating from before the early sixteenth century have been painted on wooden panels. Once prepared, a wooden panel provided a rigid, smooth, even surface for painting, allowing the artist to achieve the most detailed work. However, a large panel was heavy and unwieldy and, because it was made up of a number of planks, it required careful carpentry to make a stable structure.

Construction

The most commonly used wood for Italian panels was white poplar. Poplar has a substantial trunk so could provide wide planks, particularly if they were cut across the diameter of the trunk or tangentially, as was usually done. It is rather a soft wood, however, so the planks had to be thick in order to give them some stability: those used for the three panels making up *The Story of Griselda*, for example, are nearly 3 cm thick [18]. Poplar is liable to warp with changes in humidity and is subject to damage by woodworm, but the planks used for this narrative sequence are notably good quality, straight-grained, dense wood, with little woodworm damage [19]. Often battens were used at the back to help prevent warping. In this case they may also have been used to fix the panels to the wall of the bedroom where they were once part of the decorative scheme.

Planks were joined using glue, sometimes with the aid of dowels. The most stable structures for large panels were obtained by aligning the planks in parallel with the longest dimension. In the *Story of Griselda* sequence, this is the width and consequently the planks are arranged horizontally.

In northern Europe panels were generally constructed from oak, although other woods such as lime or beech and, after the early seventeenth century, more exotic woods like mahogany were also used. The thick forests of north-east Europe produced

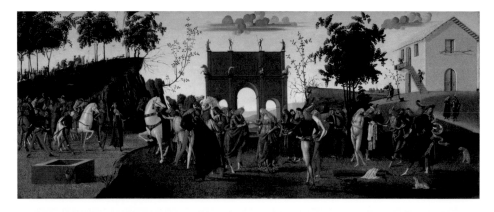

Top: 18. Master of the Story of Griselda, *The Story of Griselda, Part 1: Marriage*, about 1494. This panel, about 61 cm high and over a metre and a half long, is made of two poplar planks arranged horizontally.

Bottom: 19. *The Story of Griselda, Part 1: Marriage*. Back of the panel, showing the wood grain. The vertical channel near each end probably held a batten.

oak particularly well suited to the making of planks. The trees grew close together, giving tall, straight trunks, and Baltic oak was exported all over Europe until the mid-seventeenth century. Oak is a far stronger, more stable wood than poplar. In addition, unlike the Italian poplar planks, oak planks were usually cut radially (like the spokes of a bicycle wheel). The bark, and also usually the outer sapwood, were removed, giving quite narrow planks. Sapwood is usually softer than the heartwood at the centre of the trunk and shrinks more when dried; it is also less resistant to attack by fungi or insect pests.

We have seen that panel construction was a job requiring care and in Antwerp it was particularly well regulated. Antwerp was an important trading, manufacturing and artistic centre in the sixteenth and seventeenth centuries. One aspect of this was that carpentry and the treatment of wood used in the manufacture of altarpieces and artists' panels were strictly controlled; wood had to be properly seasoned and a panel had to be marked with the maker's registered mark. Panels were inspected and, if acceptable,

were branded with the mark of the city of Antwerp. By the early seventeenth century panels were available in a range of standard sizes and these, too, were controlled. The panel used by Anthony van Dyck for *Rinaldo conquered by Love for Armidia* [20, 21] was

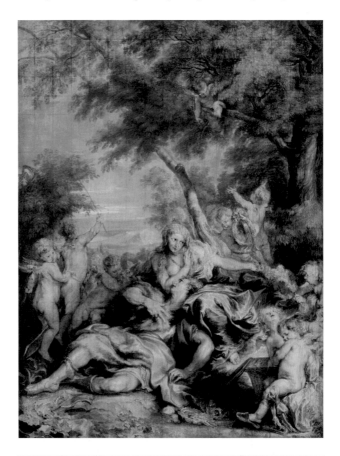

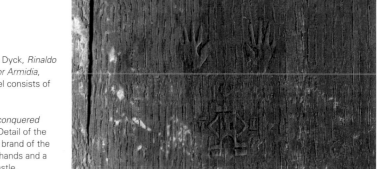

Top: 20. Anthony van Dyck, *Rinaldo conquered by Love for Armidia*, 1634–5. The oak panel consists of two vertical planks.

Bottom: 21. *Rinaldo conquered by Love for Armidia*. Detail of the reverse, showing the brand of the city of Antwerp: two hands and a stylised image of a castle.

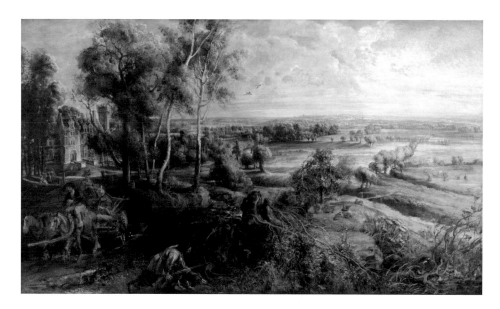

22. Peter Paul Rubens, *A View of Het Steen in the Early Morning*, probably 1636. The panel measures about 131 cm high and 229 cm wide.

clearly acceptable to the authorities as the reverse is marked with the Antwerp brand and the initials of the maker, Michiel Vriendt.

With such close regulation of panel construction by the Antwerp guild authorities, the structure of the panel used by Peter Paul Rubens for *A View of Het Steen in the Early Morning* is rather surprising, for it is made up of 19 planks, all arranged with the grain running horizontally, with another two later additions [22]. The central core of this construction may have been a small, ready-prepared panel to which the panel-maker added whatever pieces he had available to make a panel the size Rubens required. This is by no means the only example: a number of Rubens's landscapes are painted on notably complex panels and it seems that he sometimes enlarged panels in an apparently improvised manner during painting. Rubens painted his landscapes for his own pleasure or for his friends: they were not for sale. Probably, therefore, these transactions between the artist and his panel-maker were entirely private, bypassing the guild; in addition, Rubens, as a court artist, may have had some exemptions from guild regulations.

Although the use of panels declined after the seventeenth century it did not die out completely. Softwood and mahogany panels were still in use in the nineteenth century: the smallest sizes (about 24 x 16 cm or less) would even fit into a paint box and were widely used for sketches by painters such as Georges Seurat [23].

Preparation of the panel

The panel first had to be coated with a preparatory layer, or ground, as bare wood would be unsuitably rough and absorbent as a painting surface. If the panel was to be covered with gold leaf, the surface had to be completely smooth. The ground could be applied in the artist's own workshop, but as time passed it is likely that this became a separate branch of the trade.

In the fourteenth and early fifteenth centuries, fine canvas or sometimes parchment might be glued to the panel surface before the ground was applied. This would have covered faults or knots in the wood and would help to reinforce the joints; it might also have improved adhesion of the ground layer. Later, the surface covering was usually restricted to joints and flaws in the panel, using strips or shreds of parchment or canvas.

In Italy, the ground for the panel (and also frame mouldings) was made from white calcium sulphate, the mineral gypsum. The common name in Italian for gypsum is gesso; white grounds in general are often called gesso grounds, but in fact this name should be confined to those made using calcium sulphate. The gesso was mixed with glue prepared from rabbit skins or some other suitable animal material.

Cennini describes the traditional process in use in Tuscany in the late fourteenth or early fifteenth century in which two forms of gesso are used. The first to be applied is the coarse *gesso*

23. Georges Seurat, *The Rainbow: Study for 'Bathers at Asnières'*, 1883. One of several studies made for the large painting in the National Gallery Collection.

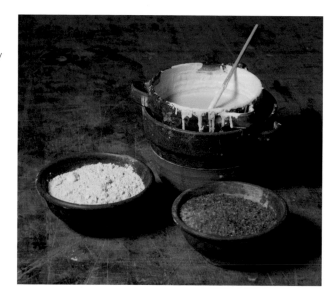

grosso, a particular form of calcium sulphate made by roasting gypsum. It is ground to a powder, sifted and mixed with the glue to form a paste, which is applied to the panel with a broad knife and scraped flat when dry. Secondly, the much finer *gesso sottile* is applied. This is prepared by soaking gypsum, or the roasted material, in water for a long time, giving a particularly fine-textured form of calcium sulphate. It is then ground and carefully mixed with the glue solution to a creamy liquid, kept warm over a bowl of hot water [24], and painted onto the panel with a soft bristle brush, applied in several coats. Cennini recommends eight: 'You may do with less on the foliage ornaments and other reliefs; but you cannot put too much of it on the flats.'

When it was dry, the surface of the gesso was scraped down until it was perfectly smooth. Cennini recommends dusting the surface of the panel with powdered charcoal; only when no remaining charcoal could be seen on the surface would it be flat and smooth enough. The result is a brilliant white, smooth and quite hard ground.

Variations of this method were followed across Italy, but over time the process became less complex and less careful: as the use of gold backgrounds declined, a perfectly smooth, flawless surface was less necessary. The ground of Michelangelo's *'The Manchester Madonna'* is particularly hard and now shows a network of fine cracks over the unpainted surface [25]. It is also pitted with air bubbles, caused by overheating the gesso mixture or brushing it on too vigorously.

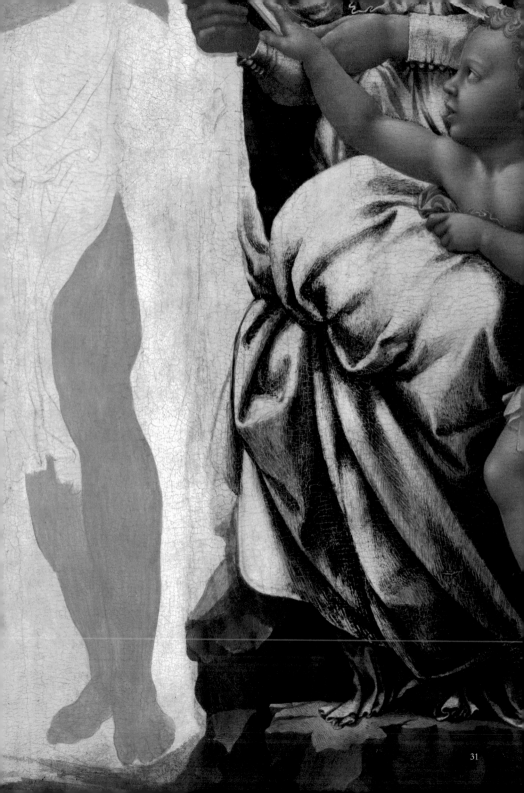

26. Peter Paul Rubens, *A Lion Hunt*, about 1614–15. The streaky brushwork and random application of the brown priming layer is particularly clear in this vigorous grisaille (that is, monochrome) sketch.

In northern Europe the white mineral used was natural chalk, mixed with a solution of glue and applied in several layers in a similar way. However, there is no equivalent to Cennini's *gesso grosso* and *gesso sottile*.

Whichever white material, gesso or chalk, was used, the ground would be absorbent. If the panel was to be used for painting in oils the ground needed to be sealed to prevent oil from the paint sinking into it. A coat of the same glue might be used, or plain drying oil. Usually, however, the oil was pigmented with a little lead white and other pigments that dry well in oil, such as red lead or ochres. Early in the sixteenth century this so-called priming layer was still usually quite light in colour, but as time went on it might be mid-brown, reddish or greyish. The priming of panels associated with the Rubens studio (although not unique to him) is mid-brown or grey and streaky, applied with a broad coarse brush [26]. It gives an overall medium tonality which the artist could use as part of the construction of light and shade in his image.

Canvas

Painting on canvas is not like painting on a smooth, rigid panel. However tautly stretched and finely woven, a canvas is never absolutely smooth; nor is it hard and rigid: it responds to the pressure of the brush. The slightly grainy surface and slight springiness of canvas encourage a looser, freer handling of the paint, appropriate both for large paintings designed to be seen from some distance away and for informal, intimate works.

Canvas gradually became the usual support for easel paintings during the sixteenth century. In fact, documentary evidence from much earlier indicates that painted cloth was common for purposes as varied as processional banners, scenery painting and domestic decorative hangings, as well as portraits and religious works. Very few of these frail works have survived, largely because they were often painted in the vulnerable medium of glue. One of these rare survivals is *The Entombment*, painted by the Netherlandish painter Dirk Bouts in the 1450s [27].

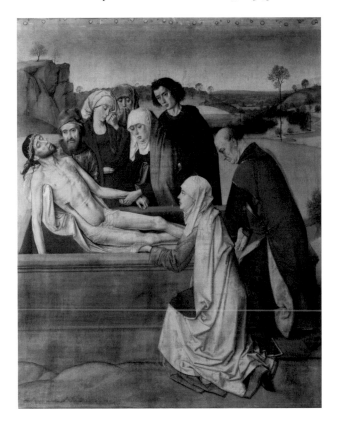

27. Dirk Bouts, *The Entombment*, probably 1450s.

28. Anthony van Dyck, *The Abbé Scaglia adoring the Virgin and Child*, 1634–5. Detail showing unpainted bottom right corner, which would be hidden behind the oval frame. The light brown ground is typical for Brussels canvases at this time.

At this time a large number of paintings on canvas were exported, notably from the Low Countries, and the composite altarpiece of which this picture once formed a part may have been painted for export to Italy. Canvas has the great advantage over panel that it can easily be rolled for transport once removed from its supporting framework; the painting is also lighter to carry.

Materials used for canvas

Linen, hemp, silk and wool cloth are all documented as having been used as supports. Cotton canvases were available from the nineteenth century and Vincent van Gogh and Paul Gauguin painted a series of works on jute canvases, made from a roll brought by Gauguin when he went to stay with Van Gogh in Arles. However, by far the most common material is linen.

Often the cloth used is a simple plain, or tabby, weave in which each weft (horizontal) thread passes alternately over and under the warp threads (those running the length of the cloth, held under tension on the loom during weaving) in a simple chequerboard pattern. It may be fine and closely woven, like that used for Bouts's *The Entombment*, or quite coarse; linen cloth has been produced in Europe for centuries for purposes ranging from handkerchiefs to sailcloth and any of these might also be used as a painting support. Anthony van Dyck's *The Abbé Scaglia adoring the Virgin and Child* [28], painted in Brussels in 1634–5, is an oval composition painted on a rectangular canvas, the weave of which can be seen through the light brownish ground layer in the

unpainted corners. This weight and weave density is fairly typical for northern European canvases of this period.

Twill weave linens (woven in such a way that the weft threads create a diagonal pattern) were also used; some show a herringbone pattern and some a complex damask pattern. The canvas used by Titian for *The Vendramin Family* is an example of damask weave, very reminiscent of cloths used as tablecloths [29, 30]. Cloths like this were available in much greater widths than other linens; this meant that large paintings like *The Vendramin*

Top: 29. Titian and workshop, *The Vendramin Family*, begun about 1540–3, completed about 1550–60. Detail of red robe of man in profile.

Bottom: 30. *The Vendramin Family*. Detail from X-radiograph of red robe, just to left of fur lining of sleeve, showing damask weave of canvas.

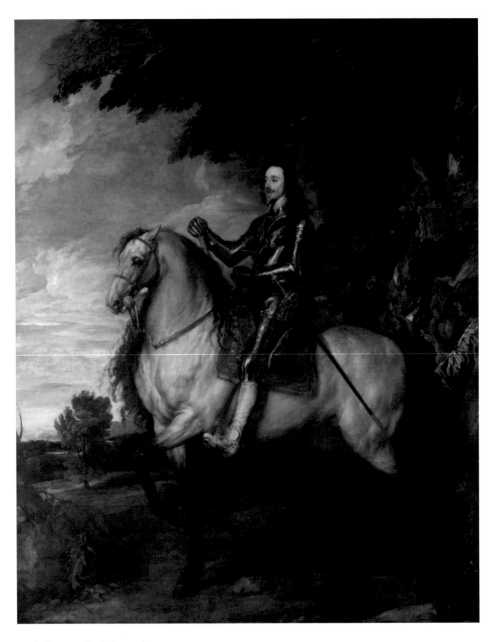

31. Anthony van Dyck, *Equestrian Portrait of Charles I*, about 1637–8. Painted on a striped ticking canvas.

Family, which measures about 206 x 288 cm, could be painted on a canvas without seams. Otherwise the artist would have to join pieces together; if this was necessary, it was usually done in such a way that the number of lengths of canvas, and therefore seams required, was minimised. Sometimes, however, the construction is more complex. This may be because the artist had to alter his composition during painting, but sometimes it seems to be due to the artist's desire not to waste canvas: Jacopo Tintoretto's *The Origin of the Milky Way* [15] consisted of two lengths of twill canvas, made up at the top and on the left by a number of smaller pieces, one of which is of a different, coarser canvas.

One of the most unexpected choices of canvas in the seventeenth century was ticking, commonly used for mattresses; like today's ticking, it was often striped very dark blue or black and white. However, it was a very strong, closely woven cloth, available in wider widths and so appropriate for large paintings. Anthony van Dyck used ticking for the huge *Equestrian Portrait of Charles I*, which measures 367 cm high and 292 cm wide [31], but the canvas consists of only two pieces of cloth with one horizontal seam.

For the artist to be able to use the canvas as a support, it had to be stretched flat and taut on a wooden framework known as a strainer; adjustable frameworks, or stretchers, were available from the eighteenth century. In the seventeenth century it was common to lace the canvas within the framework, rather than simply nailing it to the front or sides; the lacing could then be adjusted to tighten the canvas. When painting was complete, the canvas could be restretched onto a new supporting structure as required, perhaps when it reached its intended owner. When the canvas is attached to its first strainer or support, the weave is distorted, causing cusping, a pattern of arcs around the canvas. This can be seen in Bouts's *The Entombment* [32]. These original nail positions were outside the border, painted to show how the painting should be mounted on its new support when it reached its intended destination; they do not coincide with the many nail holes visible today.

Like panels, ready-prepared canvases in a range of standard sizes were available from the seventeenth century. By the nineteenth century, French ready-made canvases came in three rectangular formats, *figure, paysage* and *marine*, and a similar range could be found in England. For any one length, the *figure* canvas would be the widest and the *marine* the narrowest, and a rather similar situation exists now: a 'maritime' canvas bought from an artists' supplier today will have a narrow, rectangular format.

32. Dirk Bouts, *The Entombment*. Detail of top left corner, showing cusping (distortion of the weave) caused when the canvas was first stretched. The blue sky is noticeably brighter along the top edge of the painting, where it has been protected from light by the frame. See also [27].

Claude Monet's *Bathers at La Grenouillère* [4] is painted on a no. 30 *figure* canvas measuring 73 cm high by 92 cm wide. Painters often referred to canvases by these numbers in their letters. Early in September 1889 Vincent van Gogh mentioned in a letter to his brother Theo that he was using no. 30 canvases for a number of paintings including *A Wheatfield, with Cypresses* [33]. Later, on 28 September, he sent the paintings and added that he would be sending some smaller studies, including presents for his mother and sister: 'It's no. 10 and no. 12 canvases, reductions of the Wheatfield and cypresses, Olive trees, Reaper and Bedroom and a little portrait of me.'

Preparation of the canvas

An untreated canvas is absorbent; the binding medium would be extracted from paint applied to it, giving a very matt appearance and the risk of poor paint adhesion. The surface is also textured. Sizing, that is, treating the canvas with a solution of glue (or occasionally a dilute starch paste), reduces its absorbency; applying a preparatory layer or ground, as with a panel, reduces this absorbency still further and gives a smoother surface.

The canvas for a painting like Bouts's *The Entombment* [27, 32], where the paint has a binding medium of glue, was simply sized; no other ground layer was needed. Canvases to be painted in oil or egg tempera were sized and then given a ground. In Italy, for much of the sixteenth century, this consisted of gesso and animal glue, as for the panels (pages 29–32). The difference was that this ground was usually very thin, only filling the tiny gaps in the canvas weave: a thick gesso ground would crack if the painting had to be rolled for transport. Very frequently a second, oil-based layer was applied above this, with a similar function to the priming layer found over the white ground on panels.

33. Vincent van Gogh,
A Wheatfield, with Cypresses,
1889.

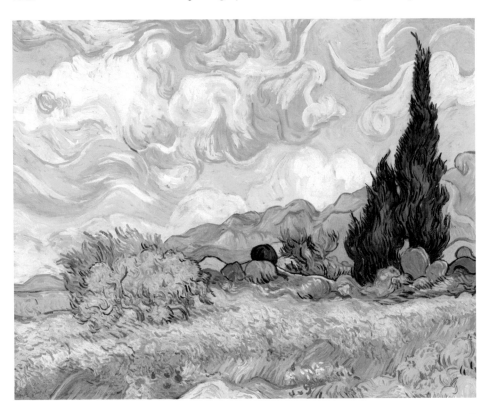

At first, this priming layer was light in colour. As time went on, darker brown or grey priming layers were preferred and, by the end of the century, this developed into the use of grounds that were themselves coloured. As we shall see, the preference for a light or dark priming layer, or a coloured ground, is intimately associated with aspects of the artist's technique: how the artist exploits the properties of oil paint and how, or if, the colour of the ground or priming is used in the construction of the painted image.

Seventeenth-century canvas grounds are often brown or grey [28], containing easily available, cheap pigments like ochres, chalk, china clay and charcoal ground in linseed oil, with lead pigments to improve the drying. Two or more layers might be applied, the lowest helping to counter any absorbency of the canvas. The ochres – earth pigments – were those available locally, recognisable in the red-brown colour of the soils of western England or central Spain. Francisco Pacheco, the father-in-law of the seventeenth-century Spanish painter Diego Velázquez, wrote that canvas 'is primed only with common red earth ground in linseed oil; they use this in Madrid'; also that 'The best and smoothest priming is the clay used here in Sevilla, which is ground to a powder and tempered on the slab with linseed oil'. The mixture was spread evenly on the stretched canvas with a knife, working the mixture well into the weave. In the large cities, artists would have been able to buy ready-primed canvas if they so desired, or they could have the canvas prepared to their specifications.

During the eighteenth century, lighter-coloured grounds came to be preferred: that used by Thomas Gainsborough for the portrait of his daughters [8] is a light brown. Nineteenth-century canvases were usually prepared with very light grounds – white, cream or pale grey, for example – and it is certainly hard to imagine Monet achieving the sparkling freshness of his landscapes [2, 4] against a dark ground. It was possible to choose a very smooth surface, prepared with two layers of the ground mixture, or a more grainy surface, where only one was applied. As a choice of canvas weights was also available, the artist had quite a range of canvases to choose from at the local colour merchant. He or she also had the option, exactly as painters in previous centuries, of ordering what was wanted, or – as Van Gogh and Gauguin did with their roll of jute cloth – of stretching the canvases and priming them him- or herself.

Metal plates

Like wooden panels, metal plates provide a rigid yet smooth surface for painting, allowing finely detailed, meticulous work. The plates, which are rarely very large, are generally copper, sometimes coated with another metal such as tin or zinc, and were particularly popular across Europe in the seventeenth century [34]. Their use may have been encouraged by the development of etching and engraving on copper during the sixteenth century, although the reuse of actual etching or engraving plates as supports for painting is uncommon. *Tobias and the Archangel Raphael returning with the Fish*, a version of a composition by the German painter Adam Elsheimer, who died in 1610, is one example: this was painted on a copper plate engraved with a coat of arms.

34. Ambrosius Bosschaert the Elder, *A Still Life of Flowers in a Wan-Li Vase*, 1609–10. Painted on a copper plate.

So that they could be used as a painting surface, the plates would be roughened and perhaps rubbed with garlic; this is sticky when first applied and acts as a wetting agent, allowing the oil paint to stick to the metal. Alternatively the plate might be rubbed with linseed oil. A thin preparatory layer of oil paint was then applied.

Paper

Paper is primarily considered to be a surface for drawing in pen or pencil, or for pastel or watercolour; it is not generally associated with oil painting, yet a surprisingly large number of works in the collection are oil paintings on paper supports, which may subsequently have been mounted onto canvas, panel or cardboard. Rembrandt's *Ecce Homo* of 1634 is a grisaille (that is, a monochrome study in which only muted greyish or brownish shades are used) for an etching, carried out on paper then mounted onto canvas.

Paper is light and portable; it provides a smooth surface and simply requires to be sized to reduce its absorbency (as described on page 39 for canvas) to render it suitable for oil painting. Seventeenth-century painters like Peter Paul Rubens were already making compositional studies using oil paint on paper, a practice which became very common later for informal, open air landscape studies which could be developed into something more formal in the artist's studio if desired. Thomas Jones [35] is one of many late eighteenth-century artists who travelled to Italy, painting in Rome and Naples, and many nineteeth-century painters used paper for rapid, direct studies of landscapes, concentrating on capturing fleeting impressions of light or weather. The National Gallery is fortunate to have a collection of these studies, the Gere Collection, which is on long-term loan.

Thicker supports of millboard, a heavy duty cardboard made from layers of paper, ready prepared with a ground, could be bought from nineteenth-century artists' suppliers. Although not very durable, millboard was cheap, light and convenient. Théodore Rousseau and Henri de Toulouse-Lautrec, among others, used millboard supports on several occasions, Rousseau for landscape studies and Toulouse-Lautrec for *Woman seated in a Garden*, perhaps a portrait of the dancer Gabrielle, painted in 1891.

Edgar Degas, who liked to work in pastel, particularly later in his career, often used tracing paper, a strange choice at first sight as it has no texture to catch the pastel. For him, however, it was convenient as he liked to rework and repeat motifs; tracing was part of this process [36].

Top: 35. Thomas Jones, *A Wall in Naples*, about 1782. The paper support, now brown in colour, is just visible on the left, between the top of the grey wall and the cream-coloured wall above.

Bottom: 36. Hilaire-Germain-Edgar Degas, *Russian Dancers*, about 1899, detail. Degas drew in charcoal on tracing paper, then applied layers of pastel, fixing the powdery colour as he worked. The tracing paper has subsequently been mounted onto a wove paper support on millboard.

Plaster

Fresco, or *buon fresco*, from the Italian word for 'fresh', is a technique of wall painting in which pigments are mixed with water and applied to freshly applied lime plaster. As the plaster dries, the pigments are bound into it, resulting in a very permanent image. The wall is first prepared with a rough plaster of sand and lime, the *arriccio*, which is allowed to dry. The image may be drawn on this layer, traditionally using a red earth pigment called *sinopia*, which has subsequently lent its name to these underdrawings. A thin layer of lime plaster, the *intonaco*, is then applied over the *arriccio*, but only to as much of the image as the artist could paint in the working day; the next day the plaster would have hardened and any unpainted plaster would have to be removed. Each section is known as a *giornata* (from the Italian for 'day'). In later centuries, artists usually prepared a cartoon and transferred the design to the fresh *intonaco* by incising with a stylus (essentially a pointed piece of wood or metal, rather like a blunt pencil) or pressing charcoal dust through holes pricked along the lines of the drawing. Alkali-sensitive pigments, such as the blue pigment azurite, could not be used in this method of painting, but they could be applied to the dry *intonaco* mixed with egg; this *fresco secco* or *secco* painting is less permanent and tends to flake off.

Fresco was very widely used for religious and domestic decorative schemes in Italy, but not in the damper climate of northern Europe. A number of paintings in the National Gallery are frescoes, transferred from their original site and mounted on canvas or another support [37].

THE DESIGN

Preparatory Studies

Once the support had been chosen and prepared, the artist could concentrate on designing the composition. Drawn or painted studies might be made for the whole composition or for individual figures or passages – draperies, perhaps, or parts of the landscape. These might include informal sketches, such as the rapidly drawn pen and ink sketches of the Virgin and Child by Raphael in which several possible positions for the baby are explored [38]. Landscape and nature studies, or details from them, could be used: Anthony van Dyck used one of the trees from an ink and watercolour landscape study in the background of the *Equestrian Portrait of Charles I* [39, 40].

The artist might use the work of other artists, past or present, as inspiration and many filled sketchbooks with drawings of figures, scenes or other works of art that caught their attention. Many had substantial collections of engravings, drawings and other works of art; and also useful items that could be used as studio props: the Stradanus studio contains pieces of antique sculpture [11]. An inventory of Rembrandt's property made in 1656 when he filed for bankruptcy shows that his personal collection included sculpture, Italian and Flemish Renaissance painting and contemporary Dutch works, books of engravings, weapons, armour and curios, and he was by no means unique in his range of interests. Textiles and carpets, often illustrated in paintings [41], would be important assets in an artist's collection.

Artists had drawn from life at least from the fifteenth-century; this was an important part of the artist's training. Carlo Ridolfi records that, as well as drawing from life, Tintoretto dissected

Previous pages: Anthony van Dyck, *Rinaldo conquered by Love for Armidia*, detail.

This page: 38. Raphael, *Studies for a Virgin and Child in her arms*, about 1506–7. British Museum, London.

Opposite page:

Top left: 39. Anthony van Dyck, *Equestrian Portrait of Charles I*. Detail of tree to the left of the horse, based on the tree just left of centre in the landscape study. See also [31].

Top right: 40. Anthony van Dyck, *Study of Trees in Full Foliage*, 1632–41?, detail. British Museum, London.

Bottom: 41. Lorenzo Lotto, *Portrait of Giovanni della Volta with his Wife and Children*, completed 1547. Carpets of the type shown here are commonly called Lotto carpets. Carpets were usually placed on tables at this time, very rarely on the floor.

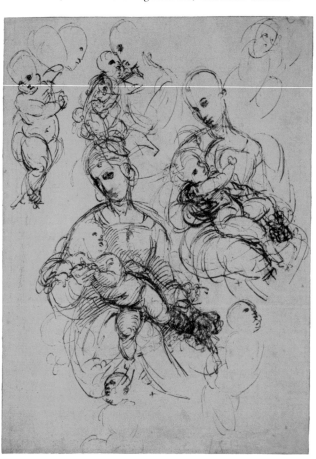

49

42. Peter Paul Rubens, *Oil Sketch for High Altarpiece, St Bavo, Ghent,* 1611–12. This small triptych would have given the cathedral authorities a good idea of the proposed composition. In fact the final altarpiece was a single panel, finally completed in 1626.

corpses to study the arrangement of muscles and Leonardo da Vinci is famous for his anatomical studies.

The last act in what might be an extensive preliminary design stage was often the production of a small scale version of the painting, drawn or painted, which allowed the painter to see how the composition would work as a whole; alterations could then be made before committing the design to its final support.

This version, which is often called a modello, would be a useful guide when the final painting was produced, particularly when, for example in the studios of Raphael or Rubens, some of the painting might be done by assistants. The small version could also be shown to the person who had commissioned the work for his or her approval. Production of small-scale oil studies was a regular part of Rubens's compositional process and a great many survive [42]. Paul Delaroche made a small watercolour study for *The Execution of Lady Jane Grey* [43], in which the only significant difference compared to the final painting [16] is in the figure of the executioner, here a rather less elegant figure, standing in profile and holding a sword rather than an axe. The range of colours used is also cooler than the dramatic reds and blacks of the finished work.

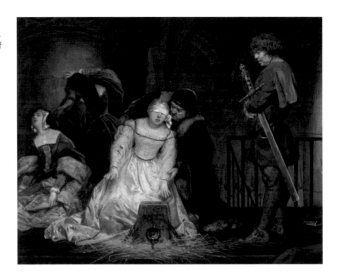

43. Paul Delaroche, *Study for The Execution of Lady Jane Grey*, 1832. Whitworth Art Gallery, University of Manchester. See also [16].

Drawing the image

Most artists transferred their composition onto the panel or canvas by drawing. This might consist simply of a few sketched lines to position the principal features relative to one another: Paul Cézanne has used a soft pencil or a Conté crayon to suggest the structure of the rocky masses in *Hillside in Provence* and to outline the trees on the left; the lines can even be seen through the thin paint [44].

44. Paul Cézanne, *Hillside in Provence*, about 1890–2. Detail of large tree on left; lines of drawing outlining the shape can be seen on the left-hand side of the foliage.

The drawing materials were similar to those used for drawing on paper or parchment: pen and ink; charcoal; a brush and ink or paint; metalpoint (a stylus of fairly soft metal); crayon, chalk and pencil. The material used depended on the type of drawing, the colour of the ground and, to some extent, the date – graphite, for example, well known today in the form of the pencil, was not in common use until the seventeenth century. Charcoal, which is easily brushed away, might be used for an initial sketch which was then defined more closely with brush and a liquid ink. Thomas Gainsborough, working on a brownish ground, used white chalk to sketch in his composition [8]. Artists working on a white or light-coloured ground used a darker material; Michelangelo used a brush and a dilute black paint for the very precise and confident drawing of the figures in *'The Manchester Madonna'*, as can be seen from the tunic of the unpainted angel on the left [25].

It is often possible to see traces of the drawing – or underdrawing, as it is called – through the paint, which tends to become slightly more transparent with time. In Raphael's *The Garvagh Madonna* [45], it is just possible to see the drawing of the Child's right foot below the painted foot – Raphael slightly changed the position during drawing and painting [46]. At any stage in drawing or painting, an artist might make an alteration so that differences between the drawing and the painting may be seen, or parts may be altered during painting. An alteration like this is known as a pentimento (literally, repentance, or change of mind).

Depending on its thickness and the pigments present, paint is often transparent to infrared radiation. If the painting has a white ground, the radiation is reflected back through the paint; if any drawing present is in a material that absorbs infrared radiation, such as black pigment, its image can be recorded using film sensitive to infrared radiation or, nowadays, with a detector which enables the image to be recorded digitally; this is known as an infrared reflectogram. We can thus see the compositional drawing Raphael made for *The Garvagh Madonna* [45, 47]. This would not be possible if the drawing had been made using red chalk as red is transparent to infrared radiation.

This example is very different to Raphael's usual rapid pen and ink sketches. Here he used metalpoint, in this case a stylus made of a soft alloy of lead and tin, which gives a fine greyish line. The white gesso ground has sufficient 'tooth' to abrade particles of the metal as the stylus is drawn lightly across it (you can try this with a paperclip on a coated paper till receipt). He

Top: 45. Raphael, *The Garvagh Madonna*, about 1509–10.

Bottom, left: 46. *The Garvagh Madonna*. Detail of the Child's right foot; its position as first drawn is faintly visible through the now more translucent red paint of the dress.

Bottom, right: 47. *The Garvagh Madonna*. Infrared reflectogram detail of the heads of the Virgin and Child, showing the clear, rather schematic drawing under the paint – simple arcs for the eyebrows and an arc and four lines for the Child's hair.

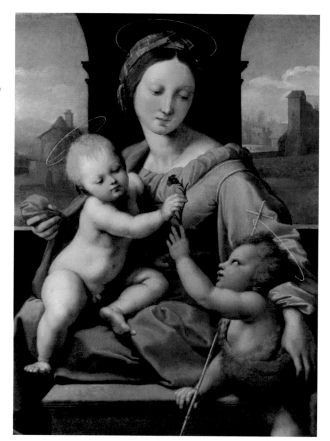

has constructed the design by dividing the panel area into four with a vertical and a horizontal line, which cross between the outstretched hands of the two children; the vertical line can be seen bisecting the Virgin's face. This helped him place the figures precisely. There are very few changes or uncertainties in the outlines of figures and little detail. This is a freehand drawing, but it is likely that Raphael, who made many drawings on this theme, was copying a compositional study made earlier.

Artists used various methods to transfer the image to the painting surface, including tracing, squaring and the use of pricked cartoons. Raphael often used cartoons, even for a painting as small as *An Allegory ('Vision of a Knight')* [48, 49]. The cartoon, drawn with pen and ink on paper is the same size as the painting and the outlines have been pricked at closely spaced intervals. To transfer the image, the cartoon was placed on the prepared panel and a small linen bag of powdered charcoal or black chalk was pressed, or pounced, over it, thus transferring the lines of the image as a series of black dots on the ground of the panel. These could then be reinforced with drawn lines.

Making cartoons and detailed drawings available in the studio meant that the artist did not have to do all the drawing on the support: if necessary, this work could be handed over to assistants. It also meant that copies of popular images could be made.

Like Raphael, Albrecht Altdorfer seems to have worked from an overall compositional plan for *Christ taking Leave of his Mother* [50]. He has used a brush and a black liquid paint or ink to draw the composition in a series of exuberant loops and swirls, delineating every fold and hatching the shadows, varying the direction of the lines according to the folds [51]. Possibly he first made a rough drawing, perhaps in black chalk. In the painting itself, Altdorfer modified the landscape considerably and made small changes to the figures.

Sometimes a grid of squares is visible in the underdrawing image. This results from the transfer of the design from a drawing by means of squaring: grids are drawn over the drawing and on the ground and the design is copied, square by square, from the drawing, enlarging or reducing it as necessary. A grid of incised lines is visible on the surface of Anthony van Dyck's *Rinaldo conquered by Love for Armidia*, made almost at the end of the painting process so that the design could be transferred to an engraving plate [52].

Top: 48. Raphael, *An Allegory ('Vision of a Knight')*, about 1504.

Bottom: 49. Raphael, *Young Man Asleep on the Ground between Two Female Figures*: cartoon for *An Allegory ('Vision of a Knight')*, about 1504, detail. British Museum, London.

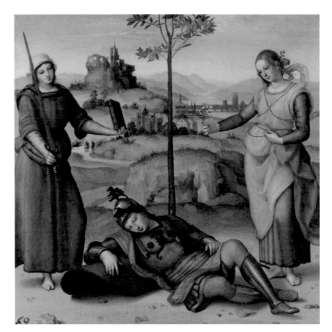

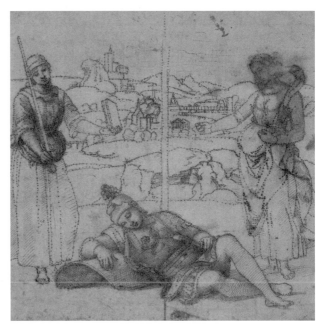

Above, left: 50. Albrecht Altdorfer, *Christ taking Leave of his Mother*, probably 1520. Detail of Saint John, right.

Above, right: 51. *Christ taking Leave of his Mother*. Infrared reflectogram detail of Saint John, showing the drawing. The hatching defining the shapes and shadows of the drapery, following the direction of the folds, can be seen.

Right: 52. Anthony van Dyck, *Rinaldo conquered by Love for Armidia*. Detail of Armidia and the cherub to her left, showing squaring incised into the paint. The artist painted cream-coloured highlights over the incised lines in several places. See also [20].

Gilding

Many of the earlier paintings at the National Gallery, dating from before about 1500, have gold backgrounds. They are generally religious subjects, showing incidents from the life of Christ or the saints and the gold background is symbolic of heaven; a gold halo, too, indicates the sacred nature of the figure represented. The same events painted a century or two later, by which time the humanity of Christ was being emphasised in Christian teaching, are given a more realistic setting; the gold has been abandoned.

The aim of these golden panels was to give the effect of solid gold, gleaming and glittering on the altar like huge metal reliquaries in the subdued, flickering candlelight of the church; this was why it was so important to give the panel a completely smooth surface. Gold was precious; the presence of gold, or any other expensive material on a painting showed that the person commissioning the work was a person of substance. This point of view gradually changed, particularly in the sixteenth century. Metals could be better represented using oil paint and the use of precious metals to decorate paintings declined.

Gold was not the only precious metal used; silver and a composite leaf made by beating gold and silver together were also used, but sadly these have frequently tarnished. The metals were beaten out to an extremely thin leaf for use. Gold (or silver) leaf, ground with a little honey or beaten egg white, could also be applied as a paint. As this was commonly stored in mussel shells it was called shell gold. Tin leaf or foil, usually gilded or painted with a transparent gold or other coloured glaze, was also used for decoration. Tin was sufficiently malleable to be pressed in a mould to produce decorative motifs, which could be glued to the painted surface. The cheapest metal of all was a form of tinsel (brass, a copper-zinc alloy).

Gold or silver could be burnished until it shone, using so-called water gilding. For this, the ground was usually covered with a layer of a red iron oxide-containing clay called bole, or an equivalent material, mixed with glue or glair – egg white beaten and left to liquify again. Bole is soft and slightly greasy; it provides a cushioned surface with some 'slip' against which the gold could be burnished, and the red colour gives warmth and richness to the thin gold leaf. The gold leaf is laid out on a padded leather cushion, cut to size with a knife if required and picked up with a gilder's tip. It is then held just in contact with

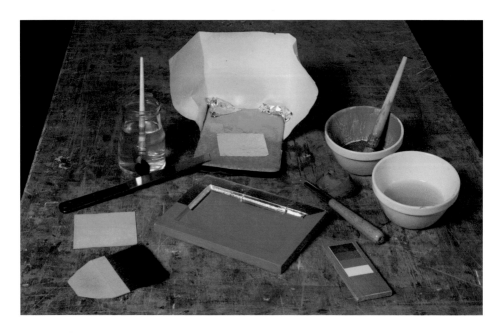

53. Gilding. Gold leaf is laid out on the gilder's cushion, protected from draughts by the parchment shield. The panel in the foreground has been prepared with a layer of reddish bole. The bowl with the brush in it contains bole mixed with glue solution; in front of it is a lump of bole. Gold is laid on the panel using the thin, flat brush on the left, a gilder's tip, and is burnished with the agate burnisher shown on the right. The small panel on the right shows the white ground, reddish bole, matt unburnished gold and shiny burnished gold.

the moistened bole and is sucked down by surface tension. It can then be burnished by rubbing with a hard polished stone, such as haematite or agate, or even a dog's tooth [53].

The gold could be decorated by incising with a stylus, or by stippling with tiny dots, tooling and punching, using metal punches. A punch, shaped like a short, blunt pencil or bearing a simple raised design, like a circle or a crescent, at one end was held against the surface and tapped gently with a hammer to indent the gold with the shaped end, repeating this to make a pattern. This gave variety to the surface as the light played over it and allowed a gold halo, for example, to be distinguished from the gold background itself. The range of decorative tools used on Italian panels is greater than on northern European panels, with quite complex patterns being created. The chalk grounds of northern European paintings are too hard to allow much use of punches; incising and stippling are more widely used [54]. The decoration could be raised as well as incised: so-called *pastiglia* decoration was modelled on the surface of the ground before gilding, using gesso or chalk mixed with glue to give a paste. It could then be gilded.

Cloth-of-gold textiles could be represented using a technique known as *sgraffito*. Cennini describes how the paint bound with egg yolk is applied over the gold and allowed to dry. A paper or parchment cartoon of the chosen design is pricked and

laid over the paint, and powdered pigment (black or white) is pressed through (or, as the paint is quite soft, the design could be transferred by drawing along the outlines with a stylus). The cartoon can be reversed or repeated as required to build up the textile pattern. To reveal the parts of the pattern that are to be gold, the still soft egg tempera paint is carefully scraped away. Finally the gold revealed can be decorated with punching or stippling. Nardo di Cione has followed Cennini's method very closely in producing the orange and blue floor covering upon which his three saints stand [55].

Mordant gilding is often used for designs on the paint surface. For this, an oil-based adhesive or mordant is painted on and when it is sufficiently tacky the gold is applied. The mordant is a rapidly drying mixture usually consisting of oil mixed with a little varnish and pigments such as red lead (or lead white for silver leaf), ochres and verdigris. The mordant is often quite thick and stiff, giving raised lines [56]. The gold is held firmly so it cannot be burnished, and it retains a matt finish. In Stephan Lochner's panel [57], mordant gilding has been used for the gold background, apart from the haloes; the brocade pattern has been created by carving short grooves into the ground before gilding. Mordant gilding, with black paint drawing, has also been used for Saint Catherine's crown and for her silver sword; here, unusually, the silver is relatively untarnished.

54. Nardo di Cione, *Three Saints*. Detail of the halo of Saint John the Evangelist photographed at high magnification. The position of the saint's head was marked by incising its outline, now filled with brown paint. The concentric circles of the halo were incised and eight punches were used in its decoration. See also [9].

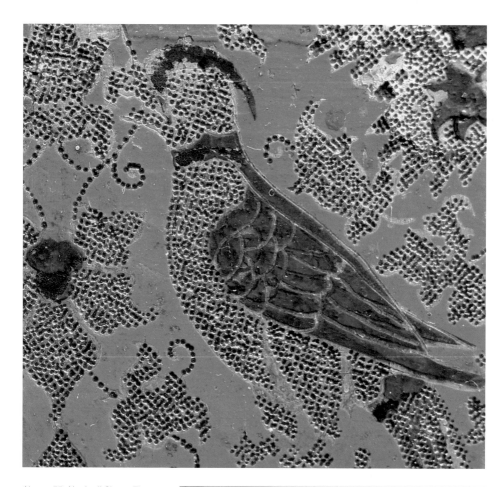

Above: 55. Nardo di Cione, *Three Saints*. Detail of *sgraffito* decoration of floor covering, photographed at high magnification. The birds have been painted in ultramarine blue over the orange-coloured red lead paint; the gold has been decorated with stippling. See also [9].

Right: 56. Duccio di Buoninsegna, *The Virgin and Child with Saints Dominic and Aurea*. Detail of the Virgin's veil, showing mordant gilding used for the kufic script, photographed at high magnification. The mordant is brownish and so thick that the lines are raised. See also [1].

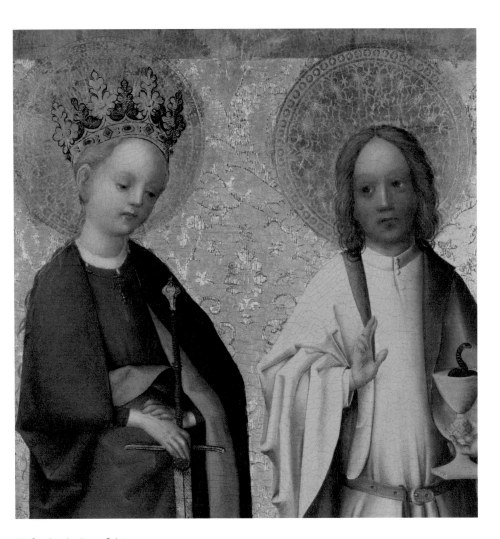

57. Stephan Lochner, *Saints Matthew, Catherine of Alexandria and John the Evangelist*, about 1450. Detail showing Saint Catherine and Saint John. The gold haloes were burnished to appear shiny and darker than the surrounding unburnished gold background, then decorated with complex patterns of tiny punched dots. The gold background was applied over a yellowish mordant and its brocade design was transferred to the panel by pouncing using a stencil.

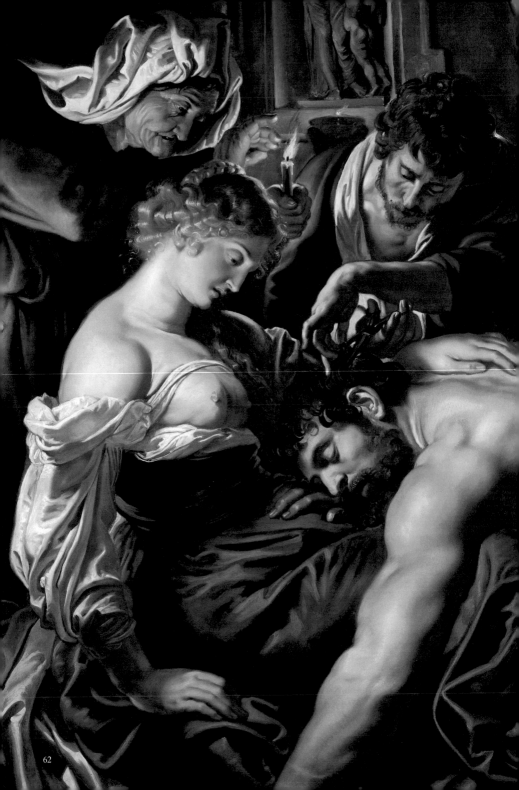

THE PAINTING

Pigments

Today, shops selling artists' materials display a tempting array of paints, conveniently packed and ready for use. For artists of much earlier times, this was not the case: the paint had to be prepared in the studio from its raw ingredients. Before the nineteenth century, the range of coloured substances – pigments – that artists could use to make their paints was more limited than it is today and in fact hardly changed over the centuries. Pigments like viridian (a bluish green), cobalt violet and cadmium yellow, staples of the artist's paint box now, were only invented after 1800. In this short book it is not possible to cover pigment history in detail, but it is discussed at greater length in another book in this series: *A Closer Look: Colour*, by David Bomford and Ashok Roy (2009).

Pigments available before 1800 included natural minerals, some manufactured minerals and pigments derived from naturally occurring dyes. Ideally, as well as having an intense, pure colour, materials used as pigments should be stable chemically, resistant to light and humidity, and should not react with other materials in the paint. In practice, few pigments fulfilled all these criteria. Some could not be used in certain combinations or in certain applications; the high alkalinity of fresco painting was particularly restricting so that some pigments had to be applied *a secco* on the dry plaster, bound in egg (see page 44).

Some natural minerals were cheap and were found all over Europe; these included the yellow, red and brown ochres and umbers, and chalk, a perfectly satisfactory white in water-based media like glue or gum (although weak and transparent in oil). Others were less common and accordingly more expensive. Deposits of the bright blue azurite, together with the related green malachite, occur in mountainous regions across central Europe, often in association with silver mines, but as one deposit was exhausted another had to be found, leading to shortages. The best quality seems to have been available in Germany, but it was expensive. The most expensive pigment of all was the deep blue ultramarine, 'a colour illustrious, beautiful, and most perfect' as Cennini describes it. Then only obtainable from the mountains of Badakhshan, in present-day Afghanistan, supplies of ultramarine fluctuated. In medieval times and long afterwards,

Previous pages: Peter Paul Rubens, *Samson and Delilah*, about 1609–10, detail.

58. Attributed to Jacopo di Cione and workshop, *Adoring Saints: Left Main Tier Panel, San Pier Maggiore Altarpiece*, 1370–1. Detail including (from right) Saint Peter, Saint Bartholomew and Saint Stephen. Pigments used include ultramarine blue (Saint Peter's robe, Saint Stephen's book), a red lake (Saint Stephen's mantle), vermilion (the robe of the saint behind Saint Bartholomew and other bright red details), lead-tin yellow, yellow ochre and a yellow lake (Saint Peter's mantle), and lead white (Saint Bartholomew's mantle). Blue azurite mixed with a yellow lake were used for Saint Stephen's green robe, while the green floor covering contains malachite.

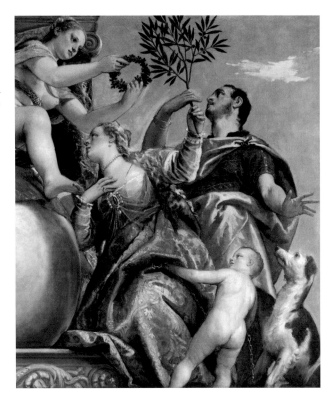

59. Paolo Veronese, *Happy Union*, about 1575, detail. Blue smalt, deteriorated to grey, is present in the sky. Verdigris was used for the greens and a cochineal red lake for the woman's dress. The yellow pigments include two types of lead-tin yellow and orpiment; the orange includes the arsenic sulphides realgar and pararealgar.

ultramarine came into Europe through Italy, particularly Venice; Italian painters certainly seemed to have access to the best quality [58].

Vermilion, the natural mineral cinnabar, was mined in Spain, but its preparation from mercury and sulphur had been known since the ninth century. The poisonous yellow pigment orpiment (an arsenic sulphide) was also known in a synthetic as well as the natural mineral form. The manufacture of lead white, red lead and blue–green verdigris was already well known in classical Rome. Other manufactured pigments were associated with crafts other than painting, principally ceramics, glass and dyeing: the blue glass pigment smalt, the lead–tin yellows and lead antimonate, or Naples yellow, all had links with the production of ceramic glazes or coloured glass [59].

The natural red and yellow dyes employed in textile dyeing could be made into translucent pigments, usually containing alumina. These pigments are called lakes. The dyes included the plant dyes madder, for red, and weld, for yellow, and more expensive red dyes obtained from certain insects: kermes (the

medieval 'grain'), lac and cochineal. Blue indigo is already insoluble and could be used without further preparation. Other plant colorants could be used in watercolour – sap green is an example – but were not suitable for easel painting.

The first purely synthetic pigment was Prussian blue, discovered between 1704 and 1710 and widely available by the 1720s. As an alternative to the uncertain supplies of ultramarine and azurite and the poor quality of smalt and indigo, both of which tend to lose their colour for different reasons, Prussian blue was an immediate success [60]. A century later, it was joined by a range of brilliant pigments based on the discovery of chromium and other metals, which were produced by the chemical industry that emerged during the nineteenth century. Cobalt blue, the cobalt violets, the green chromium oxide pigment viridian and the chrome yellows, used so expressively in the work of Van Gogh [33], the cadmium yellows and, most significantly, the inexpensive synthetic analogue of natural ultramarine all appeared during the nineteenth century, vastly increasing the range of colours available to the artist.

The extent to which painters mixed pigments or paints together varied, depending on need. The green pigments available, for example, were not entirely satisfactory and more useful or attractive greens might be obtained by mixing a blue with a yellow pigment, or by adding yellow to a bluish green like verdigris or viridian, or even by mixing yellow and black. The production of a true purple pigment in the nineteenth century was particularly interesting. Previously, purple colours had to be made by mixing pigments, or by applying a layer of transparent red paint over a mixture including a blue pigment [61]. A particularly effective mixture, used by Rubens in *Samson and Delilah*, consisted of black, lead white and a crimson lake pigment [62]. Claude Monet, however, had pure, intense cobalt violet pigments at his disposal [63].

Preparing the paint
Grinding paint is a two-stage process. First the pigment must be ground to a very fine powder. The depth of colour of some pigments, such as the blue mineral azurite and green malachite, is dependent on particle size so these pigments are often coarsely ground to achieve the deepest colour. The powder is then ground with the binding medium.

Top: 60. Thomas Gainsborough, *Mrs Siddons*, 1785. Detail of dress, painted using lead white and Prussian blue.

Bottom: 61. Hans Memling, *The Donne Triptych*, about 1478, detail. Lady Donne, on the Virgin's left, is wearing a purple dress painted using ultramarine and a red lake, while ultramarine, over an azurite and lead white underpaint, was used for the Virgin's dress. The binding medium is oil.

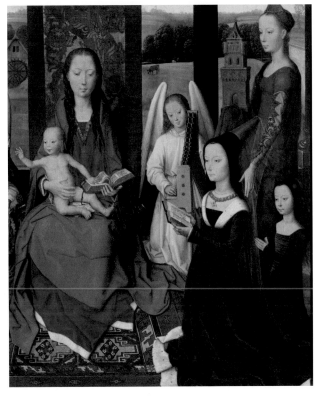

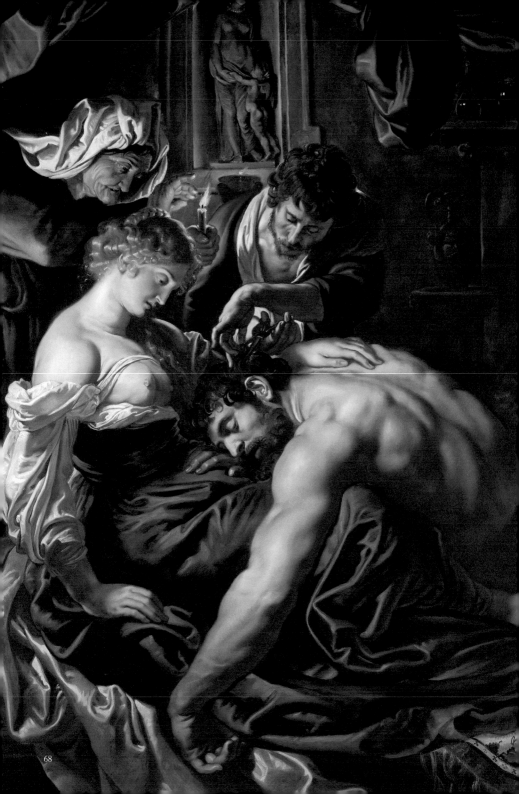

Opposite page: 62. Peter Paul
Rubens, *Samson and Delilah*, about
1609–10. Detail showing principal
figures and background, left. The
purple curtain has been painted
using a mixture of a red lake,
charcoal black (which is a bluish
black) and lead white.

Above: 63. Claude-Oscar Monet,
Irises, about 1914–17. Detail of
purple irises on left. Monet used
a mid-tone of cobalt violet for the
reddish-mauve touches in this
detail. Rather dry, greyish-blue
mixtures of cobalt blue and lead
white have been dragged over
the dry paint beneath, mixtures
of viridian and lead white, lemon
chrome yellow and synthetic
ultramarine, giving a mesh of
brushwork.

Watercolour

Watercolour is the medium of manuscript illumination, of
miniature painting and of immediate and evocative sketches
on paper, exemplified by the work of Joseph Mallord William
Turner in the nineteenth century. Dirk Bouts's frail painting of
The Entombment [27] is perhaps a more unexpected example. The
pigments are mixed with a medium of gum, glue or glair which
can be dissolved or easily mixed with water. Once this is dry
the medium barely covers the pigment particles and the colours
appear matt and at their brightest. Although the paint can be
applied quite thickly, it can then crack as the film has no elasticity
or strength. It also remains soluble, so that fresh paint applied
over existing paint tends to disturb it. Typically white paper plays
an important part in the construction of a watercolour image; the
touches of light in the foliage of a tree or a sparkle of water can
all be given by the white paper where it is left uncovered by the
paint. The reflective quality of the paper shining through the thin
washes of colour gives the painting its freshness and brilliance [64].

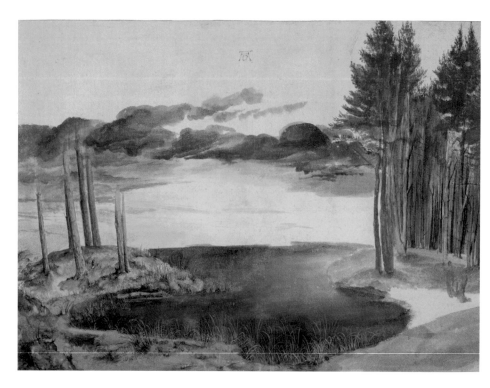

64. Albrecht Dürer, *Landscape with a Woodland Pool*, about 1496. British Museum, London.

Egg tempera

Egg has been used as a binding medium from early times, the white for manuscript illumination, the yolk for painting on panels – egg tempera painting. Once dry, an egg tempera film is tough and resilient. The paint has a soft sheen, with cool, clear colours. The pigment, ground with water to a paste like thick cream, is mixed with egg yolk. Cennini recommends the use of about equal amounts of pigment and egg; this gives a rather liquid paint. However, egg has particular properties that dictate how the paint is used. The mixture must be made immediately before use because, as the water evaporates, the egg rapidly forms a skin (familiar to anyone washing up plates on which egg has dried). As we have seen in the atmospheric detail from the landscape in Verrocchio's *The Virgin and Child with Two Angels* [3] it is possible to use egg tempera paint diluted like watercolour to give washes of colour, but usually it was not diluted as much as this. It is not possible to build up the paint thickly as it will shrink and crack or flake when the water evaporates; it is not easy to paint with wide sweeping brushstrokes. The paint cannot

be manipulated or blended like oil paint while wet as it will peel away, perhaps removing the layers already applied. The paint is therefore applied in quite short hatched or stippled strokes, laid side by side [65].

The shades of colour required for each area of the painting were pre-mixed: the darkest shade for shadows, and mixtures containing increasing amounts of white for the mid-tones and highlights. The artist then applied the paint in hatched strokes working from dark to light until the area was covered, then going back to the darkest areas, to reinforce the deepest shadows, and the lightest, for the final highlights. Flesh was usually underpainted with the pigment green earth, which showed through the flesh paint to give cool shadows and half-tones, seen very clearly in the face of the Virgin in Duccio's painting; here the darkest tone for shadows was a mixture of ochres, white and black known as *verdaccio*.

Over a century and a half later, Domenico Ghirlandaio and his pupil Michelangelo were using the same system in a most sophisticated way. The green underpaint can be seen clearly in the unfinished faces, arms and legs of the angels on the left in Michelangelo's *'The Manchester Madonna'* [25]; in the flesh of the

71

66. Domenico Ghirlandaio, *The Virgin and Child*, probably about 1480–90. Detail of the Child's head and shoulders, showing the very fine, linear brushwork. The green underpaint is apparent, for example in the cool shadow around the nose; deeper shadow on the left shoulder is given by a *verdaccio* mixture.

other figures, smoothly painted with short, dense strokes, it gives a subtle shimmering milky quality to the paint, but is not visible. Ghirlandaio's network of paint strokes is slightly more open, allowing the green underpaint to be seen [66].

Oil

Oil is the most versatile paint medium. It allows the most life-like representations of the visible world, from drops of water on a leaf to the gleam on polished metal, in a way that is impossible for watercolour or egg tempera. The oils used in painting are so-called drying oils. Like many cooking oils, they contain unsaturated fatty acids. Fatty acids contain chains of carbon atoms joined together by bonds. The bonds may be saturated – two carbon atoms are joined to each other and also have sufficient hydrogen atoms attached to them to give a stable structure – or unsaturated. Here, there are too few hydrogen atoms present to

satisfy the two carbon atoms and they join together by a so-called double bond. This can be broken, permitting further reactions. Depending on the number and sequence of the double bonds in the molecule, fatty acids may be able to link together – or cross-link – forming a network. The fatty acids in many cooking oils cannot readily do this, but those in drying oils – linseed, walnut and poppy seed – can. The oil slowly forms a rubbery polymer and over the years, as the cross-linking reactions continue, this hardens to give a tough film. The most efficient drier is linseed oil. Poppy seed oil is the least efficient drier, but also yellows the least.

Because oil dries slowly, it remains workable for long enough for the painter to manipulate the paint; the brushstrokes can be blended so that they are no longer visible. Oil can be pre-thickened, by heating or by being left to stand, or a little varnish can be added; but all these alter its working and drying properties. Driers such as lead salts can be incorporated to speed up drying, as pigments differ in how well they dry when mixed with oil; lead- and copper-containing pigments are good driers, while lakes and ultramarine are poor driers.

Pigments vary in the amount of oil they need to make a satisfactory paint; lead white does not require a great deal, while a red lake and the blue pigments ultramarine and azurite require more. Too much oil can cause problems, such as paint wrinkling. However, any pigment may require less oil when the paint is machine-ground than when ground by hand, simply because hand grinding is less efficient.

Until the nineteenth century, paint was ground by hand; the artist could supervise the grinding and have the paint made up precisely to his liking. The paints resulting from hand-grinding the various pigments have slightly different handling properties; in the manufacture of nineteenth-century machine-ground tube paints these differences were minimised and all had a similar texture, which some painters did not like. Some, such as Vincent van Gogh, complained that there was too much oil in their paint. He was also concerned by how finely the pigments were ground, wondering if coarsely ground pigments would take up less oil. The concern with the amount of oil present led some painters to remove excess oil from their paint by placing it on blotting paper before use. Edgar Degas and Henri de Toulouse-Lautrec sometimes diluted their paint with *essence*, turpentine spirit, so that the paintings had the transparency and matt appearance of watercolour; Degas's *At the Café Châteaudun* is a typical example [67].

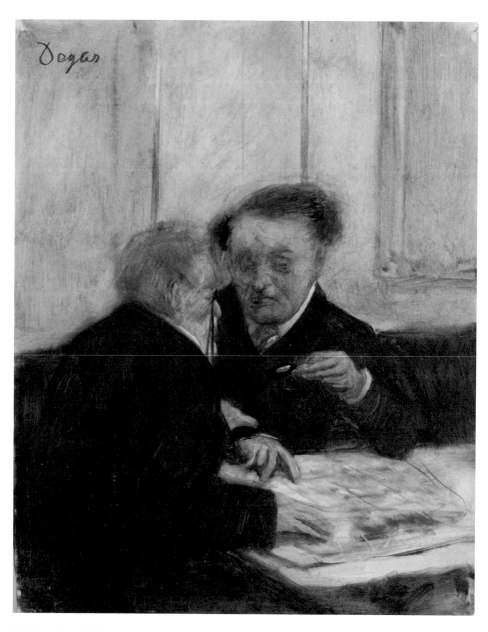

67. Hilaire-Germain-Edgar Degas,
At the Café Châteaudun, about
1869–71.

Left: 68. Raphael, *The Garvagh Madonna*. Detail of the Virgin's red dress. See also [45].

Right: 69. Andrea del Verrocchio and assistant (Lorenzo di Credi), *The Virgin and Child with Two Angels*. Detail of the Virgin's red dress. See also [91].

Why egg tempera and watercolour look different from oil paint

Let us take two paintings of the Virgin and Child, both Italian, quite close in date, Raphael's *The Garvagh Madonna* [68] and Verrocchio's *The Virgin and Child with Two Angels* [69] and compare the painting of the Virgin's red dress. Both painters have used a red lake pigment, very probably containing the same dye (kermes). Verrocchio has used egg tempera; the separate short brushstrokes are clearly visible and he has added more or less lead white to achieve lighter and darker shades, giving shape and volume to the drapery folds, with pure red lake in the deepest shadows. Even allowing for the fact that the red pigment has faded and now has a brownish tinge, the red egg tempera paint looks cool and slightly translucent, rather than the rich, more transparent, deep red that Raphael has achieved using oil paint, building the paint in several layers with pure red lake at the surface. Why does the red lake in egg medium look less intense in colour than it does in oil?

The way in which light interacts with paint influences how the colours appear to us. Light is bent, or refracted, as it travels from air to water, or water to glass, or air to oil paint, because it travels more rapidly in air than in water, glass or paint (this is why a swimming pool looks shallower than it really is). This property can be measured for water, or glass, or oil, or a pigment,

70. Lac lake pigment powder mixed with (middle) egg tempera medium (water and egg yolk) and (right) linseed oil. The smear of dark red oil paint on a glass grinding slab (inset) is very translucent.

71. Lead-tin yellow, high quality blue azurite and red lac lake; compare the colours of the powders and the pigments ground in linseed oil.

and is known as its refractive index. In the case of paint, the greater the difference in refractive index between the pigment and the binding medium, the more opaque the pigment appears. The same pigment can therefore look very different in oil and egg tempera because oil has a higher refractive index than egg tempera, or water-based gum or glue media. A lake pigment, like that used by Verrocchio or Raphael, or the lac lake pigment illustrated [70] has a refractive index that is higher than that of egg tempera, but not much higher than that of oil. Thus the lac lake looks more translucent in oil, and Raphael's lake in oil looks more translucent than Verrocchio's in egg tempera. The red colour of the lac lake oil paint is very intense, or saturated, again like Raphael's, more so than in egg tempera; the dry powder in air is a bright bluish crimson. We can compare the effect of oil on other pigments: blue mineral azurite has a higher refractive

index than lac lake so the optical effect of grinding it in oil is less marked; lead-tin yellow has a much higher refractive index than either and its colour is unchanged [71].

All pigments appear brighter and more opaque in an aqueous medium, like the gum typical of watercolour paints or glue distemper, as the refractive index of the medium is always lower than that of the pigment.

Dry egg tempera paint has a silky sheen, but it is still light and bright, shown by the clarity of the sky in Sassetta's *Saint Francis and the Poor Knight* and *Francis's Vision* [72]. The influence of the binding medium is most dramatically illustrated by the appearance of blue pigments: all show the brightest, clear blue colour in watercolour or egg tempera [65, 73]. In oil, azurite, a greener blue, can look greenish [5, the Virgin's robe]. Ultramarine, which has a low refractive index, is translucent in oil and its colour becomes a very saturated dark blue [61].

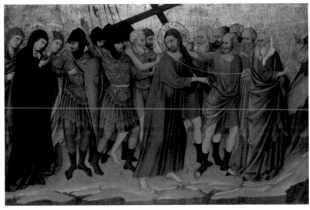

Above: 72. Sassetta, *Saint Francis and the Poor Knight* and *Francis's Vision*, 1437–44. Detail of landscape in the background.

Right: 73. Ugolino di Nerio, *The Way to Calvary*, about 1324–5. The blue pigment used here in egg tempera medium is azurite, also used in the greens and subtle purples. Compare this with ultramarine blue, used by Duccio [65], and with azurite used in oil by Quinten Massys [5].

The effect of the colour of the ground layers

When an artist paints in egg tempera or oil on a white or very light-coloured ground, the paint will gain luminosity from the reflective quality of the ground, particularly if it is very thin.

In an early fifteenth-century oil painting, such as *A Woman* by the Netherlandish painter Robert Campin, flesh tones are extremely thinly painted and much of the modelling of the face is assisted by the effect of light reflected by the white ground through the thin, translucent paint; only the strongest highlights are emphasised with very light pink or white paint [74]. We can learn how Campin achieved this luminous effect by looking at an X-radiograph of the painting. If a painting is X-rayed, the passage of the X-rays through the painting is impeded to a greater or lesser extent, depending on the pigments present, the thickness of the paint and the density of the support. This produces an image, an X-radiograph. A familiar comparison is the picture we see if the dentist X-rays our teeth: flesh looks hazy on the developed film; denser bone looks a streakier grey and and a dental amalgam filling, containing mercury, looks opaque white. Most pigments are metal salts so those containing heavier elements like lead (lead white, lead-tin yellow) or mercury (vermilion) tend to block the radiation. Paint containing these pigments appears light on the developed X-radiograph, unless, like the flesh paint in Campin's

Left: 74. Robert Campin, *A Woman*, about 1435, detail.

Right: 75. *A Woman.* X-radiograph of the woman's face. Only the thickest lead white paint, highlighting the woman's temples, nose and mouth and parts of her headdress, appears light in this image; otherwise the paint is too thin, even where the pigments used contain heavy elements like lead.

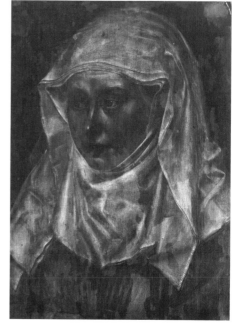

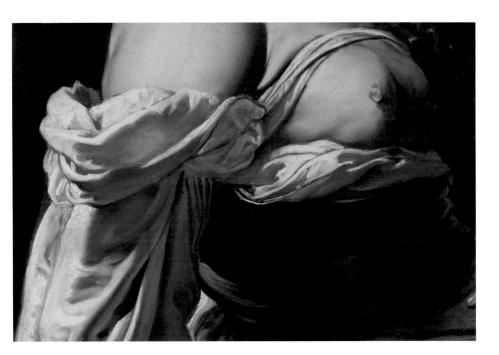

76. Peter Paul Rubens, *Samson and Delilah*. Detail of Delilah's right sleeve and crumpled drapery under her breast. The golden mid-tones and light shadow are given by the lower paint layer, the brown priming. The deeper shadows have been accentuated with darker paint. Rubens often uses reddish paint to give a glowing shadow to flesh paint, as he has here at the right of Delilah's breast. See also [62].

portrait, it is very thinly painted, in which case it may appear dark. Campin's paint is thin so only the highlighted areas on the woman's face, more thickly painted with lead white, appear light on the X-radiograph [75]. On the other hand, dark areas must be quite thickly painted on such a light ground.

The painter working on a darker ground proceeds differently. Very light colours, like the highlights on flesh, must be built up using more opaque paint, but dark shadows can be painted thinly, which is visually very effective. In addition, painting a light colour thinly over a darker underlayer allows the underlayer to contribute to shadows and mid-tones in a very subtle and natural way, giving the cool shadows in flesh paint, for example. Rubens makes use of the streaky coloured priming on his panels to contribute to the half-tones and shadow in the white drapery and Delilah's breasts in *Samson and Delilah* [76]. The opalescent appearance of the subtle shadows in the paint on her shoulder and neck is also given by the darker paint or drawing beneath the pale flesh colour.

We can now see how artists could use a dark-coloured priming or ground in constructing the image. The canvas used by the Italian painter Michelangelo Merisi da Caravaggio for *Boy bitten by a Lizard*, painted in 1595–1600, was prepared with a warm, mid-brown ground. He has used this colour to give the

77. Michelangelo Merisi da Caravaggio, *Boy bitten by a Lizard*, 1595–1600. Detail showing head and shoulders. The brown ground contributes much of the colour of the parts of the painting half in shadow.

half-shadow of the boy's left cheek and the inside of his shoulder [77]. He applied dark brown paint very thinly under the boy's chin and along his upper arm to give the deepest shadow, while the opaque pink paint of the lighter areas of the boy's flesh, painted quite thickly to cover the brown ground colour, stands out strongly against it. This technique of painting flesh is quite different to that seen in Robert Campin's portrait where the ground is white.

Caravaggio exploited the brown ground when painting the boy's white shirt, using it to obtain the cool greyish areas of the folds, half in shadow, by the simple but effective means of applying the lead white paint thinly and quite streakily over it, a method very similar to that used by Rubens. The thin, light paint over the warm brown looks cooler (greyer or bluer) than it would if painted over another light colour. (This optical effect can be seen by looking at the back of the hand of a pale-skinned person: veins are dark red in reality, but, seen through translucent pale skin, they look bluish.)

78. Sir Thomas Lawrence, *William Wilberforce*, 1828. National Portrait Gallery, London. The sitter's head, set against a halo of brown paint, is more or less complete; the remainder of the composition has only been drawn.

Portrait painters working on lighter-coloured grounds frequently placed the head of their subject against an area of dark paint, against which they could build up accurate and solid-looking flesh tones. The dark area of the evolving landscape in Gainsborough's unfinished portrait of his daughters [8] served this purpose and the effect can be seen more clearly in Sir Thomas Lawrence's unfinished portrait of William Wilberforce [78].

Painting in oil

In constructing the painting, many artists followed a similar procedure which hardly varied in its essentials well into the nineteenth century. First an underpaint was applied over the drawing, perhaps in monochrome, building up the overall areas of light and shade in the composition. Alternatively the artist might use muted versions of the intended colours to give a basic dark-to-middle tone. This underpaint is often described as dead colouring, particularly for the work of painters from the seventeenth century onwards. The underpaint stage is seen in Gainsborough's unfinished painting in the sketchily applied flesh colours of the girls' arms and the older girl's yellow dress [8]. The colour may be chosen to contribute to the final effect desired, in a similar way to the use of green underpaint for flesh in egg tempera painting [25, 66]. The ease with which oil paint can be used, however, means that a great many artists constructed parts or most of the image in a single, direct application of paint, working the colours together to model the forms, perhaps over a previously applied underpaint. This is often known as painting *alla prima*, or, in nineteenth-century France, *au premier coup*, a term bringing to mind the work of painters like Claude

79. Rembrandt, *A Woman bathing in a Stream (Hendrickje Stoffels?)*, 1654, detail. The unpainted brown underpaint is clearly visible along the bottom of the shift and also through the scumbled (see page 84) grey paint of the hand in shadow. The impasto of the white highlight and along the edges of strokes of thick white paint can be seen to the right of her hand. The long strokes of greyish paint comprise several greyish-white shades blended during painting.

Opposite page: 80. Jan van Eyck, *The Arnolfini Portrait*, 1434.

Monet [2, 4] and Vincent van Gogh [33]. However, it was also used earlier, perhaps most graphically by Rembrandt [79]. In *A Woman bathing in a Stream*, the woman's shift was rapidly and confidently painted over the dry, brownish underpaint, which contributes to the shadows in the final image. Sometimes Rembrandt seems to have dipped his brush into several shades of whitish paint at once, which can then be seen, side by side, in the fluent strokes of paint.

The combination of the different pigments and types of oil allow many ways to manipulate the paint. Brushstrokes can be blended until they are invisible, particularly if a pre-thickened oil (like today's stand oil) is used, then the paint dries with a mirror-like finish. When this is combined with the use of pigments translucent in oil, the paint is effectively a glaze. A glaze is a thin layer of transparent paint applied over a more opaque layer, such as the deep-red shadow in the folds of Delilah's drapery [62] or the intensely green pools of shadow in the folds of Arnolfini's wife's dress [80]. The modelling of these draperies is to some extent carried out in the opaque paint layers beneath: mixtures including vermilion in the red, verdigris and lead-tin yellow in the green. The green glaze contains verdigris and the oil used has been thickened by heating; this also raises its refractive index, bringing it even closer to that of the verdigris. In addition, van Eyck added a little pine resin varnish, giving a thick paint rather

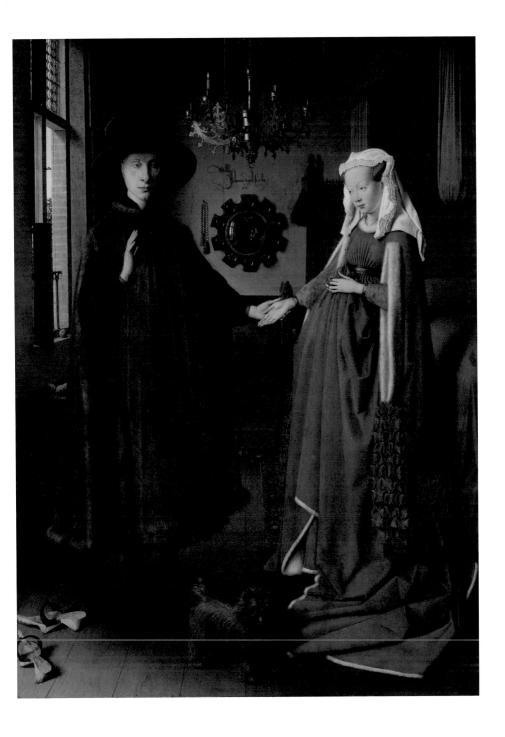

like soft jelly. It was clearly difficult to apply with the brush and, like Quinten Massys [6], Jan van Eyck had to blot the paint with a fine linen cloth and also use his fingers to even it out [81]. He was not alone in this: Raphael, Titian and countless other painters have been found to use their fingers to blend or fashion the paint.

The transparency of glass or the delicacy of a fine fabric veiling flesh or a darker fabric beneath can be given by a few wisps of thin, opaque light-coloured paint over a darker background [77, 79]. This technique is known as scumbling: the opaque paint is simply dragged thinly over the paint below, using a brush carrying very little paint so that the often darker paint beneath is still visible through the thin, broken layer. Francisco de Zurbarán used this method to show the reflected light creating the shape of the plate in *A Cup of Water and a Rose* and, most delicately, the insubstantial reflection of the rose petals, the pale pinks and whites barely veiling the dark paint beneath [82]. In fact, metal can be rendered with greater realism in oil paint than that obtained using real metal leaf, as we can see from Jan van Eyck's brass chandelier in *The Arnolfini Portrait*, painted with deft highlights and scumbles of opaque lead-tin yellow paint on the brown-painted metal [80].

The application of oil paint to another passage of paint that has not yet dried, painting wet-in-wet, allows colours to be blended, but it also allows the artist to convey immediacy, the colours remaining unblended: the breeze over the grass in Van Gogh's *Long Grass with Butterflies* [83]; the dappled reflections and leaves of water lilies in the water in Monet's *The Water-Lily Pond* [84]. As oil paint holds its shape, it can be applied thickly so that it stands up from the surface in relief as an impasto: the emphatic brush marks give a marked texture to the paint. This is seen in Rembrandt's paint [79], but also in the dabs of green paint used for water lily leaves and in Van Gogh's swiftly painted butterflies.

The shape of brush the artist has used can often be deduced from the painting. The long strokes of fluid paint used by Rubens to paint Delilah's dress [62] would require the use of a large, well-bodied round brush. Cézanne has used flat brushes, working with parallel, diagonal strokes for parts of *Hillside in Provence* [44] and *Bathers* [85]. Jan van Eyck used the handle of the brush to inscribe the bristles of the brush hanging on the wall of Arnolfini's room into the wet paint [86] and Gustave Courbet was one painter who sometimes used a palette knife, rather than the brush, to apply the paint with hard, straight-edged strokes [87].

81. *The Arnolfini Portrait.* Glaze on green dress photographed at high magnification, showing spotty appearance resulting from blotting the paint with a cloth. The whorls of the fingermark in the centre of the detail are just visible. See also [80].

82. Francisco de Zurbarán, *A Cup of Water and a Rose*, about 1630. Detail showing reflection of rose in the metal plate.

83. Vincent van Gogh, *Long Grass with Butterflies*, 1890. Detail with butterflies on left. The artist has applied strokes of paint over other paint that has dried, but the blending of strokes of colour, such as the greens near the butterflies, shows that much of the work was done while the paint was fresh and still wet. The butterflies are rendered in blobs of whitish paint, outlined in blue. Gaps in the paint show the unpainted ground on the canvas.

84. Claude-Oscar Monet, *The Water-Lily Pond*. Detail of middle of pond on left under bridge. Light-green paint dabbed onto the canvas, with a marked impasto on one side, represents water lily leaves, while the pale pinks and whites of the flowers are rendered with thick paint, strands trailing from the brush stroke. The paint beneath was applied in dry blue and dull green paint, dragged over the ground and leaving uncovered areas. See also [2].

85. Paul Cézanne, *Bathers (Les Grandes Baigneuses)*, about 1894–1905. Detail showing brush strokes.

86. Jan van Eyck, *The Arnolfini Portrait*. Detail of brush hanging on the wall in the background, photographed at high magnification. The artist has used the pointed end of the handle of his brush to draw the bristles in the wet paint. See also [80].

Top: 87. Gustave Courbet, *Beach Scene*, 1874. Detail of the beach in the foreground, just above the signature, showing the hard-edged strokes of paint applied with a palette or painting knife.

Bottom: 88. Georges Seurat, *The Channel of Gravelines, Grand Fort-Philippe*, 1890. Detail of building on the right, showing Seurat's characteristic dotted brushwork and carefully calculated colour harmonies and contrasts.

A few painters developed such characteristic brushwork that it gave its name to a style of painting. Georges Seurat's dots of contrasting colours, often complementary – blue and orange, for example – placed close together, were intended to be fused into a great range of tones by the eyes of the viewer and this gave rise to the name Pointillism [88], given, rather mockingly, to the technique by critics in the 1880s.

Pastel

Pastels are first mentioned in the sixteenth century, when they were used for drawing, but they became popular in the following centuries for more formal painting, particularly portraiture. Pastels are essentially solid, crumbly sticks of pigment which have been very finely ground in water and mixed with a proportion of ground chalk, gypsum or China clay and usually a little gum [89]. The mixture is rolled or formed into convenient lengths and allowed to dry. As the powdery colour easily brushes off, pastel pictures are usually sprayed with a fixative (usually a solution of a resin dissolved in alcohol or other volatile solvent), during working if necessary, to fix the pigment without saturating the colour and darkening it. The results are pure, bright pigment, without the influence of binder.

Painters would need large sets of pastels to achieve all the colour effects required as one cannot lighten a colour simply by adding white; the colour has to be premixed as another pastel. Edgar Degas used at least four blues and a similar number of reds, pinks and greens in *After the Bath, Woman drying herself*, together with a large range of other colours [90]. Degas rubbed, smudged and fixed his colours as he worked; he also wet them, which gives a characteristic smeared, pasty appearance.

Right: 89. Selection of pastels. Note the number of different blues in this example and many more shades are available.

Opposite page: 90. Hilaire-Germain-Edgar Degas, *After the Bath, Woman drying herself*, about 1890–5. Detail of the woman's head and back. The white pastel of the towel, near the woman's red hair, was wetted, giving a smeared appearance. The woman's flesh is coloured with white, a creamy yellow, pale orange, pink and mauve pastels, together with black, applied in free strokes over blended colour beneath.

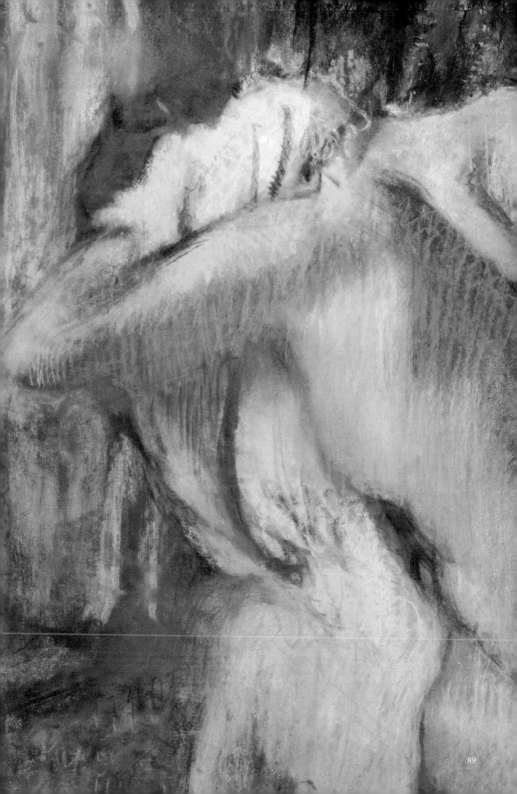

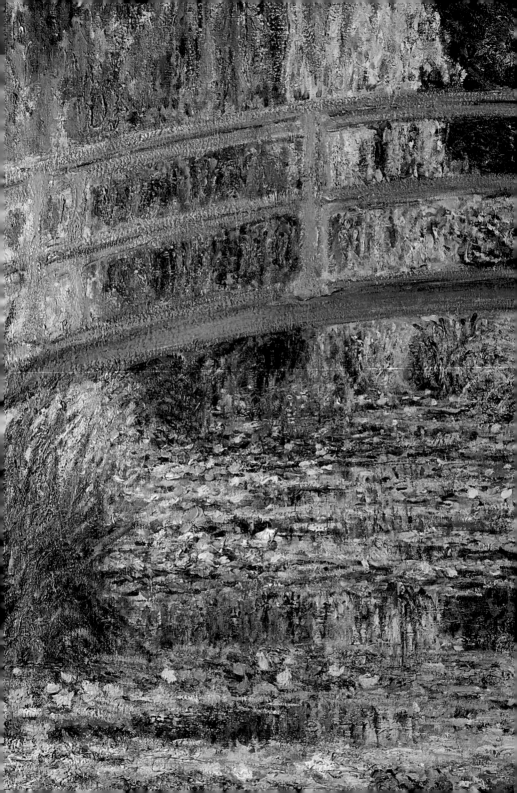

THE FINISHING TOUCHES

The final act for the painting might be to varnish it. This would unify the surface visually, compensating for unequal drying of the paint causing some areas to look matt and others not, perhaps, and filling in tiny gaps in the paint film. The varnish also protected the paint surface. It might be temporary, perhaps to show its commissioner the work in progress; egg white was sometimes used for this as it could be removed quite easily. A more permanent varnish was made from a natural resin heated with oil, or dissolved in a solvent such as turpentine spirit. Modern varnishes are often made using synthetic resins.

Varnishing the painting altered its appearance by causing the pigments to appear more saturated in colour and by giving it a glossier surface. For paintings on canvas in a glue medium, intended to have a quite light, bright and matt appearance, this would be a considerable, and to modern eyes disastrous, change; while some of the surviving paintings of this type may have been varnished at a later stage in their history, there is no evidence that it was done at the time.

For paintings in oil or egg tempera, some time was usually
allowed to elapse before varnishing was done; as Cennini says,
'the secret of the best and most beautiful kind of varnishing is
this: that the longer you delay after painting the panel, the better
it is'. As paintings have usually been varnished at a later stage in
their histories and long after they were painted, usually we do not
know when this first varnishing was done. In fact the painting
could be varnished at the request of the owner, several years after
it left the artist's studio.

Some painters, including Camille Pissarro and Claude Monet,
were very reluctant indeed to have their paintings varnished,
although it was often done by dealers to make their works look
more 'finished' in a conventional sense and thus easier to sell.
For their brilliant, open paintwork, sparkling against the light
canvas, this would have been the antithesis of what was intended:
the representation of the fleeting changes around them through
brushwork and colour [2, 4]. The appearance of paintings today
is affected by the effects of time, their condition and the way in
which they have been conserved and restored over the years; this
is the subject of *A Closer Look: Conservation of Paintings*, by David
Bomford et al (2009).

The End Result

This book has set out to show how a set of very simple
ingredients – coloured minerals, manufactured pigments, egg
and oil – have been mixed and manipulated by artists over the
centuries to give an endlessly variable range of effects and images.
Far from diminishing the glory and mystery of works of art, a
description of the materials and an examination of how artists
achieved their aims only increases our respect and admiration for
their achievements and resourcefulness.

Verrocchio's delicate modelling and refined techique in *The
Virgin and Child with Two Angels* shows the subtlety and luminosity
that is possible with egg tempera paint [91]. Oil is versatile in a
way that egg tempera can never be. Even the fact that, unlike
egg tempera, oil is slow to dry, has been exploited by artists from
van Eyck and Rubens to Monet and Van Gogh to great effect.
For centuries the range of pigments available was relatively
limited, but this was no barrier to artistic invention. Indeed
Monet, who used 15 pigments for *Bathers at La Grenouillère*
early in his career in 1869, very deliberately restricted his palette
to pairs of blues, reds and greens, with cadmium yellow and

91. Andrea del Verrocchio and assistant (Lorenzo di Credi), *The Virgin and Child with Two Angels*, about 1476–8.

lead white, for *Lavacourt under Snow* 10 years later. Painting changed very dramatically in the later nineteenth century; the carefully constructed image, built up in layers or closely woven brushstrokes, was to a large extent abandoned, replaced by a desire to represent the immediacy of the play of light, the fleeting image, the here and now. This is reflected in the rapid application of paint, the dabs and touches – one colour piled onto, and into, another. We can see this in the work of Claude Monet and Vincent van Gogh, or the constant changes in the work of Edgar Degas, as the artists attempted to keep pace with the world around them.

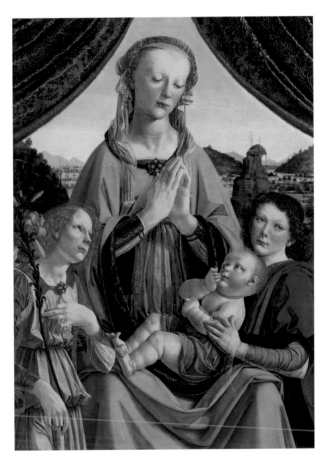

FURTHER READING

P. Abrahams, *Beneath the Surface: The Making of Paintings*, London 2009.

P. Ball, *Bright Earth: The Invention of Colour*, London 2008.

D. Bomford (ed.), *Art in the Making: Underdrawings in Renaissance Paintings*, London 2002.

D. Bomford, J. Kirby, A. Roy, A. Rüger and R. White, *Art in the Making: Rembrandt* (revised edition), London 2006.

D. Burnie, *Light*, London 1999.

'Colour by design', in D. Denby, C. Otter and K. Stephenson, (eds), *Chemical Storylines A2; Salters Advanced Chemistry*, 3rd edition, Harlow 2009.

J. Dunkerton, S. Foister, D. Gordon and N. Penny, *Giotto to Dürer: Early Renaissance Painting in the National Gallery*, New Haven and London 1991.

J. Dunkerton, S. Foister and N. Penny, *Dürer to Veronese: Sixteenth-Century European Painting in the National Gallery*, New Haven and London 1999.

J.S. Mills and R. White, *The Organic Chemistry of Museum Objects*, 2nd edition, Oxford 1994 (reprinted 2003).

D.V. Thompson, *The Practice of Tempera Painting*, New York 1962.

The *National Gallery Technical Bulletin*, published annually, is a record of research carried out at the National Gallery, London, and contains many articles related to materials and techniques of painting and the artists discussed in this book. *Technical Bulletin* articles are also available online, at www.nationalgallery.org.uk/technical-bulletin

The following *Art in the Making* titles are now out of print, but can be found in good libraries:

D. Bomford, J. Dunkerton, D. Gordon and A. Roy, *Art in the Making: Italian Painting before 1400*, London 1989.

D. Bomford, S. Herring, J. Kirby, C. Riopelle and A. Roy, *Art in the Making: Degas*, London 2004.

D. Bomford, J. Kirby, J. Leighton and A. Roy, *Art in the Making: Impressionism*, New Haven and London 1990.

Quotations taken from:

p. 21 E. Armitage, *Lectures on Painting, delivered to the Students of the Royal Academy*, London 1883.

p. 30, p. 64 and p. 92 Cennino d'Andrea Cennini, *The Craftsman's Handbook: The Italian "Il libro dell'arte"*, trans. D.V. Thompson, New York, London 1960.

p. 38 L. Jansen, H. Luijten and N. Bakker, (eds), *Vincent van Gogh: The Letters*, 6 volumes, London 2009; available online at http://vangoghletters.org.

p. 20 C. Ridolfi, *The Life of Tintoretto and of his Children Domenico and Marietta*, trans. C. and R. Enggass, University Park Pennsylvania and London 1984.

p. 40 Z. Veliz, (ed.), *Artists' Techniques in Golden Age Spain: Six Treatises in Translation*, Cambridge 1986.

ACKNOWLEDGEMENTS

I am most grateful to Joanna Cannon, Jill Dunkerton, Susan Foister, Rachel Giles, Douglas Gilmore, Jan Green, Larry Keith and Ashok Roy for their very helpful advice and comments during the writing of this book; to Colin Harvey and Isabella Kocum for special photography; and Rob Atkinson, Suzanne Bosman, Rachel Billinge, and Marika Spring for technical advice and images.

Picture Credits

FSC
www.fsc.org
MIX
Paper from
responsible sources
FSC® C012285

OTHER TITLES IN THE *CLOSER LOOK* SERIES

Allegory
Erika Langmuir
ISBN 978 1 85709 485 5

Angels
Erika Langmuir
ISBN 978 1 85709 484 8

Colour
David Bomford and Ashok Roy
ISBN 978 1 85709 442 8

Conservation of Paintings
David Bomford with Jill Dunkerton
and Martin Wyld
ISBN 978 1 85709 441 1

Deceptions & Discoveries
Marjorie E. Wieseman
ISBN 978 1 85709 486 2

Faces
Alexander Sturgis
ISBN 978 1 85709 464 0

Frames
Nicholas Penny
ISBN 978 1 85709 440 4

Saints
Erika Langmuir
ISBN 978 1 85709 465 7

Still Life
Erika Langmuir
ISBN 978 1 85709 500 5